IMAGES
of America

VENTURA COUNTY
MOTOR SPORTS

Tony Baker

To Ed

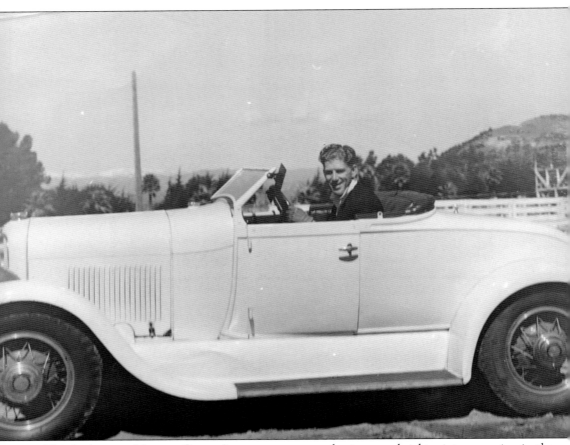

This look across Ventura County's motor-sport scene begins on a bright winter morning in the early 1930s. The locale is West Front Street, by the county fairgrounds, as Ventura resident Jim Hogan proudly poses with his new 1932 Ford roadster. The stylish young dude behind the wheel of a fast car personifies the image of the early county scene. In the background is the old Seaside Park horse-racing track, and the hill at right is Grant Memorial Park. Just visible in the distance, left of center, are the snowcapped Los Padres Mountains. (Courtesy of Norman Ward.)

On the Cover: Ventura resident Hugh Tucker in his 1928 Chevrolet roadster races against the Davis & Ingram Mustang funny car in the 1966 National Hot Rod Association National Championships at Indianapolis, Indiana. (Courtesy of Hugh Tucker.)

IMAGES
of America

VENTURA COUNTY
MOTOR SPORTS

Tony Baker

ARCADIA
PUBLISHING

Published by Arcadia Publishing
Charleston, South Carolina

Printed in the United States of America

Library of Congress Control Number: 2015948908

For all general information, please contact Arcadia Publishing:
Telephone 843-853-2070
Fax 843-853-0044
E-mail sales@arcadiapublishing.com
For customer service and orders:
Toll-Free 1-888-313-2665

Visit us on the Internet at www.arcadiapublishing.com

Dedicated to Robert Olinger

CONTENTS

ACKNOWLEDGMENTS

I would like to thank members of the hot-rod community of Ventura County for the generosity they have shown me and for their contributions of photographs and memories that made the production of this book possible. Special thanks go to my friend Hugh Tucker, for sharing his story with me; to Dwayne Bower of Ojai, for all his contributions and his enthusiastic support of this project from its beginning; and to Ken Duttweiler, for spending a lot of his valuable time answering my questions. Thanks also go to Mark Mendenhall of the Mendenhall Museum, for the use of his archive, and to my friend C. Darryl Struth, for his continued support. Biggest thanks go to the many contributors whose photographs make up this book: Dave Barker, Bob Carter, J.C. Campbell, Ed Chamberlain, Howard Clarkson, Cliff Dysart, Jim Fain, John Farr, Sam Foose, Mike Hart, Bud Hammer, Bernard Hammer, Wanda Jackson, Paul Kiunke, Ed Langlo, Lee Ledbetter, Brian Lewis, Keith Loomis, Richard Martinez, Paul Mercado, Fred Notzka, Pete Peters, Bob Richardson, Lary Reid, Manuel Saenz, Ernie Sawyer, Jim Sharpe, Steve Smith, Dave Stoll, Jack Taylor, Jess "Vonte'" Torres, Norman Ward, Dennis Williams, Walt Williams, and George Wilson. For their assistance in spotting technical details, I would like to thank my good friend, racing pioneer Lee Hammock, and my neighbor D. Rocky. For their essential services, thanks go to Desiree Gonzales, my text editor, and to Ryan Rush, who edited the images. For the use of their fine facilities, I would like to send special thanks to my friends Adam Randall, Tiffanie Wright, and Josh McNutt, operators of Squashed Grapes Wine Bar and Jazz House.

Lastly, I would like to thank Jeff Ruetsche and all at Arcadia Publishing for their support and assistance and for giving me this opportunity.

I have worked hard to keep this book factual and accurate, and I hope the readers will enjoy it but also forgive any errors they may spot.

INTRODUCTION

For over 100 years, motor sports have been immensely popular all over America, and one of the major hotbeds of activity has been California. A sense of style, combined with technical innovation, were the hallmarks of the California scene. The region also possessed an attitude, seemingly unique: that there were no limits to anything. Particularly when it came to speed.

As a large part of the American population migrated to California in the years preceding and following World War II, in tandem with the rise in car culture, it was inevitable that motor sports of all kinds would find fertile ground there. One place involved in almost every aspect was Ventura County.

Home to numerous hot-rod car clubs since the 1930s and motorcycle clubs since the 1920s, the 1,884-square-mile county offered a wide variety of terrains that were perfect for testing the limits of any type of machine. There were long, straight roads that cut through the lemon groves, and a beautiful highway drive that ran north along the coast to the county line. For motorcyclists, there were miles and miles of mountain roads and plenty of hills to climb. The proximity to Los Angeles made for easy access to the various speed parts manufacturers that made the city their home. It also made it easy for Ventura's clubs to establish a close relationship with the huge hot-rod community there.

Besides the city of San Buenaventura, the county contains nine other towns and several smaller communities. In the postwar era, these were typical American agricultural towns, with the oil industry being the other main employer in the area. In the 1950s and 1960s, communities like Ojai and Oxnard had their own teenage car clubs and cruise nights, just like other towns all over the country.

The sport that dominates Ventura County's history is drag racing, which got its start in the region. Although possessing its own legitimate track for only a very short time, the county has produced many of drag racing's pioneers and many technical innovations. Quite a few county natives who got their start in automotive class or working at the local machine shop went on to become successful in the field of automotive technology.

As the sport of drag racing grew in popularity in the 1950s and 1960s, legally sanctioned drag strips began appearing all over the region. Goleta, Saugus, Santa Maria, and Santa Ana, among others, were already in business by the early 1950s, with more to follow. Ventura was not among these. An attempt by local hot-rodders to persuade the board of supervisors met with no success, and all legal racing had to be done in other counties. In 1970, a large group of Ventura street racers organized and finally persuaded the powers that be to allow a trial race meet at an empty former Air Force base in Oxnard. The trial meet, and the short racing season that followed, were more successful than anyone could have imagined, and it looked like Ventura County would finally have its own motor-sport venue. It was not in the cards, though. Complaints about the noise, rising land values, and other factors led to the end of that effort.

While drag racing predominates local history, almost all other forms of racing have had strong followings, too. Motorcycle hill climbs were being held as early as 1925, with a heavily attended event occurring at La Conchita, up on the Rincon. The region's earliest motorcycle club, the Ventura Twin Wheelers, was established in 1923 and lasted into the 1960s. Motorcycling is as popular in Ventura County as it ever was—probably more so.

Jalopy racing was a very popular spectator sport on the central coast, and Ventura County was well represented by the Tri-Valley Racing Association, a group of local racing enthusiasts who held races at their track in Oxnard.

The relatively young sport of off-road racing also made quite an impact on the local scene. The county's proximity to the Mojave Desert, combined with its mostly hilly terrain, ensured that local enthusiasts already had an affinity for driving off the pavement. Some of the same Ventura residents who made their mark in sports like dirt-track and drag racing went on to become well-known in off-road racing as well.

The postwar development of artificial lakes and reservoirs to accommodate population growth in Southern California led to yet another venue that Ventura residents could use to express their desire to go fast. Small fiberglass hulls mounting huge blown engines began appearing in the newly constructed waterways.

Times are changing, and it appears that the fossil-fueled, internal combustion engine that has been the basis for all things motor sports may finally be heading down the road to obsolescence. Whether or not this is true, the allure of speed will still exist to certain people, and motor-sport enthusiasts of Ventura County will still be involved in its pursuit.

One

CRUISING THE
OJAI VALLEY

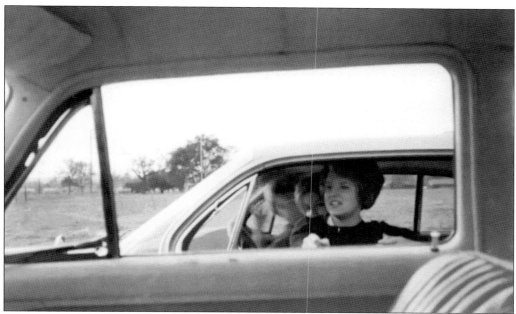

The Ojai Valley, located 18 miles north of Ventura, contains the small agricultural and resort town of Ojai, plus the nearby villages of Meiners Oaks and Oak View. These places were like most other small American towns in the late 1950s, with a large contingent of high school students and young adults under the sway of the burgeoning car-culture movement. There were various car clubs, impromptu drag races, and, of course, cruise nights. Cruising was a popular Saturday pastime with the teens in Ojai, like everywhere else in the country. The local drag was to run from the old oak tree that stands at Canada Street, down Ojai Avenue a half mile, to the bowling alley past the corner of Shady Lane. Here, Marilyn Cooper (foreground), future wife of Dwayne Bower, and her friends sit in their bubble-top 1961 Oldsmobile, making contact down by the old Ojai Elementary School, near Montgomery Street. (Courtesy of Dwayne Bower.)

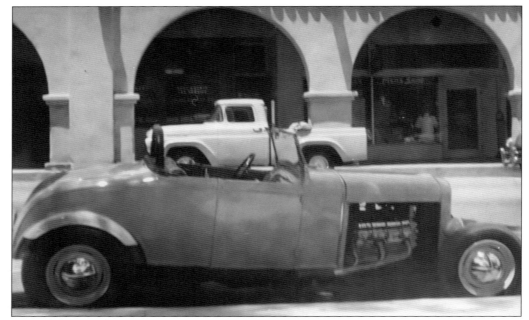

Walt Williams's 1932 Ford roadster is parked across the street from the Arcade on a typically hot day in 1956. Overhead engines were still a novelty in hot rods in those days, and Williams was able to acquire an Oldsmobile 303-cubic-inch V-8 of 1950 vintage, complete with Hydramatic transmission. Automatic transmissions were a comparative rarity, too. (Courtesy of Walt Williams.)

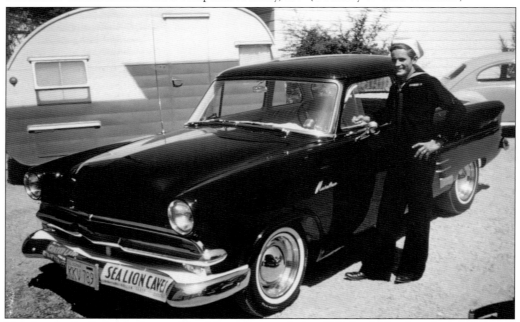

Naval reservist Dwayne Bower, 20, of Ojai poses with his 1953 Ford Mainline business coupe. The coupe was equipped with Ford's base model 223-cubic-inch, straight-six engine. A bit of mild custom work was done with some discrete nosing and frenching, and a few other modifications. Bower graduated from Nordhoff High School in 1961. (Courtesy of Dwayne Bower.)

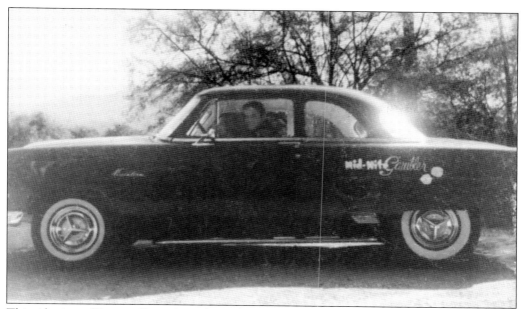

This side view of Dwayne Bower's car shows the lake pipes with cut-out just visible behind the front wheel, as well as spinner hubcaps. Bower purchased the car from his best friend, Lee Fitzgerald, who did the custom work. Bower drove the cruiser all over the western United States on various road trips. The script over the rear wheel reads "Mid-Nite Gambler," which was the title of a song by pop singer Frankie Ray. (Courtesy of Dwayne Bower.)

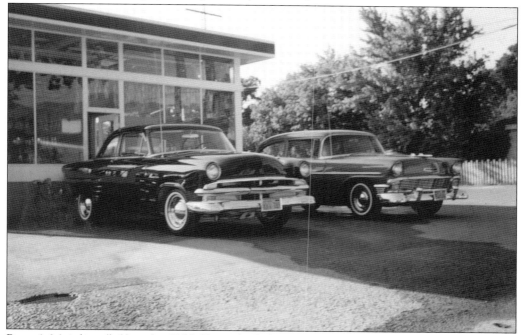

Bower's Mainline (left) and a 1956 Chevrolet belonging to Bill Clegg are seen one morning at Watson's Chevron station on Ojai Avenue. Clegg's Harbor Blue Chevy ran a 283-cubic-inch small block with a six-pack and a four-speed. (Courtesy of Dwayne Bower.)

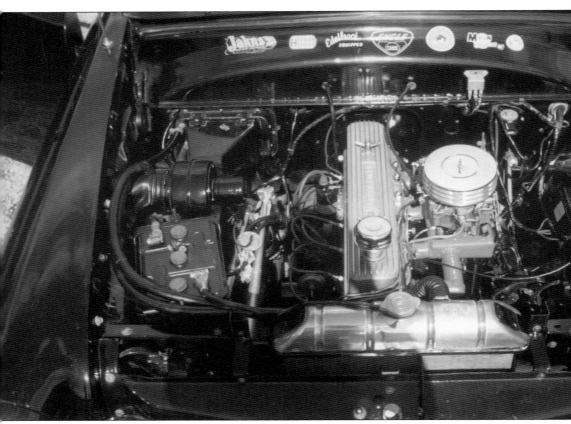

This is the well-detailed engine compartment of the Mainline Ford. Dwayne Bower bored out the engine to 235 cubic inches and milled the head. The four-barrel carburetor is mounted on a homemade intake, and the exhaust exited through a set of custom pipes. The black box on the right is the sending unit for the Sun tachometer. Note the Offenhauser valve cover. Everything under the hood was finished in either black, orange, red, or chromium, making for a very attractive layout. Note the speed-equipment manufacturer's stickers proudly displayed at the top. With this engine, Bower could beat most Chevy sixes and Ford flatheads. (Courtesy of Dwayne Bower.)

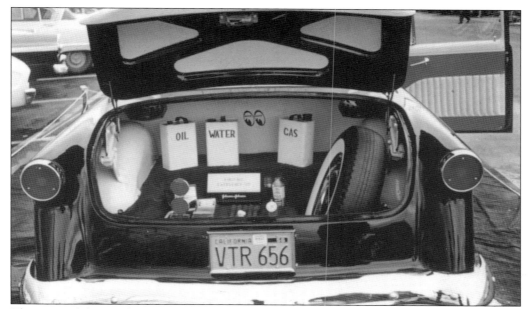

This view of the trunk of Dwayne Bower's Ford shows the typical accessories on display for car shows. Included here are cans to hold oil, water, and gas, as well as reflectors, flares, and a first-aid kit. The simple taillight lenses that replaced the stock units can also be seen. (Courtesy of Dwayne Bower.)

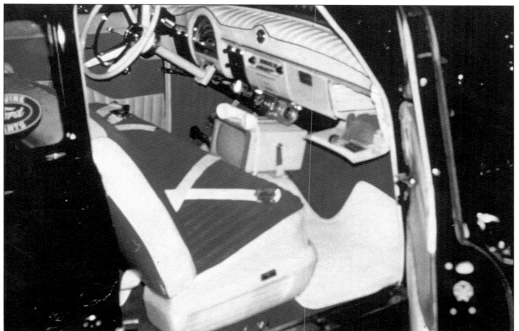

The well-done interior of Bower's custom is on view here. Besides the extensive tuck-and-roll upholstery work, done in Tijuana, the interior featured a (nonfunctioning) television set and telephone. Such luxury accoutrements were necessary to make an impression on car-show judges. (Courtesy of Dwayne Bower.)

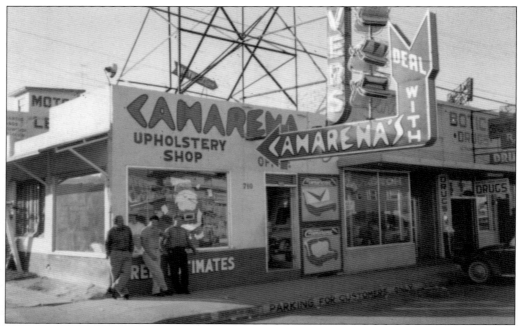

When a car customizer in Southern California wanted excellent-quality upholstery for the interior of his car, he went south of the border to Tijuana, Mexico. There, a leather or vinyl interior in a variety of styles and colors could be had for a fraction of the cost of having it done in the United States. The shop in the below photograph has various examples of its wares on display. The young men on the left appear to be examining the finish on Dwayne Bower's Ford Mainliner. (Both, courtesy of Dwayne Bower.)

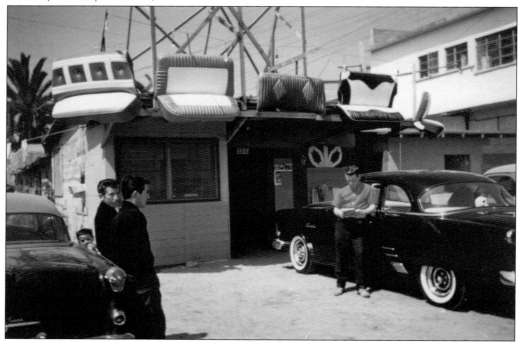

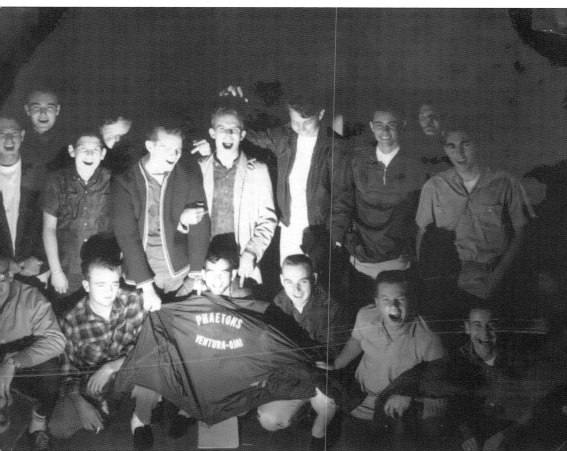

Pictured here are members of the Phaetons, a club that had chapters in both Ojai and Ventura. The Ojai branch was made up of the usual combination of local high school students and mechanics from farms and the oil fields. Many members were formerly in the Valley Trackers, an Ojai club from the early 1960s. Visible in this poor-quality Polaroid instant photograph taken in 1963 are, from left to right, (first row) Joe Knupp, Jim Sharkey, Dave Barker, two unidentified men, and Dennis Reid; (second row) Ronnie Reid, Dale Kingsbury, Joe Wingate, John Rains, Chip Allison, and three unidentified. (Courtesy of Dave Barker.)

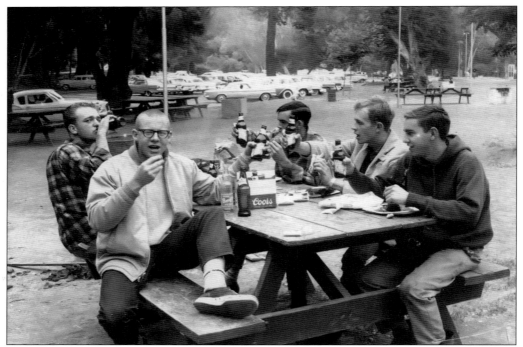

Camp Comfort Park, on Creek Road just outside of Ojai, was popular with car clubs from all over Ventura County as a place to kick back and enjoy a few cool ones. Pictured here are, from left to right, Ron Reid, Dale Kingsbury, Joe Wingate, Dave Barker, and Dennis Reid. They were all members of the Phaetons. (Courtesy of Dave Barker.)

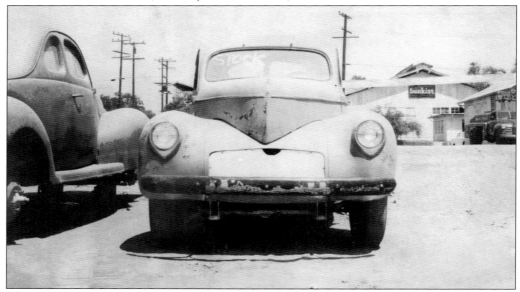

This 1940 Willys coupe had been sitting for years in a farmer's field off of Old Baldwin Road when it was purchased by the Phaetons for $25. The coupe was completely stock and original when found. The Phaetons planned to use it as a club project car and drag racer. (Courtesy of Dave Barker.)

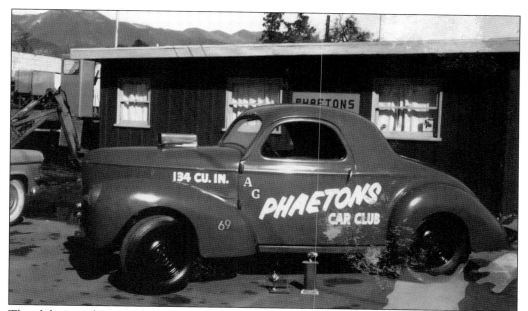

The club wasted no time stripping out the interior panels and seats in an attempt at a very low-budget drag racer. The impressive-looking scoop on the hood supplied air to the not-so-impressive stock 134-cubic-inch Willys flathead four-cylinder engine. The location is the Phaetons' clubhouse in a small industrial park on South Fulton Street, where the railroad tracks ended. (Courtesy of Dave Barker.)

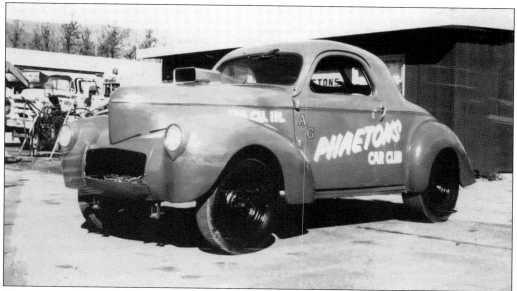

The coupe was painted an orange-red color using several spray cans, and a professional painter was hired to do the lettering. With only 61 horsepower, the inline four-cylinder engine barely had enough power to turn the cheater slicks that the club mounted on the rear end. In spite of this, the Willys still managed to pick up a few trophies racing in F/Stocker class against much smaller Volkswagens and other cars. It would go on to have quite an illustrious career in racing. (Courtesy of Dave Barker.)

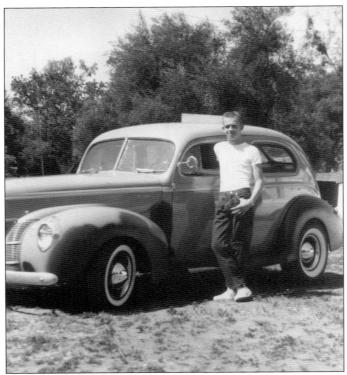

Ojai native Dave Barker, a 1962 graduate of Nordhoff High School, was a founding member of the Ojai Valley Trackers car club and was with the club when it merged with the Phaetons. At left, he poses with the first of many cars he would own, a 1940 Ford two-door sedan. As shown below, Barker had an affinity for the 1940 Ford models. The setting is a car show at the county fairgrounds at Seaside Park in the early 1960s. The buildings in the background were torn down during the Highway 101 expansion, although some of the palm trees still line Front Street. Also visible are the foothills of the Taylor Ranch and Mount Diablo (right). (Both, courtesy of Dave Barker.)

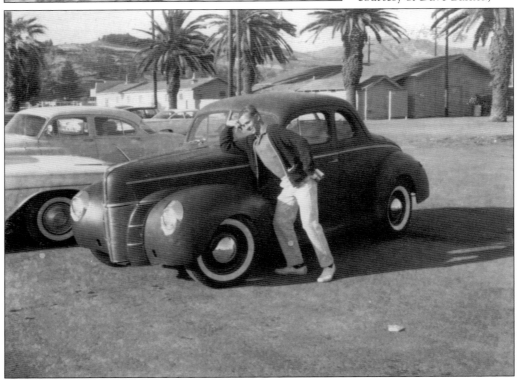

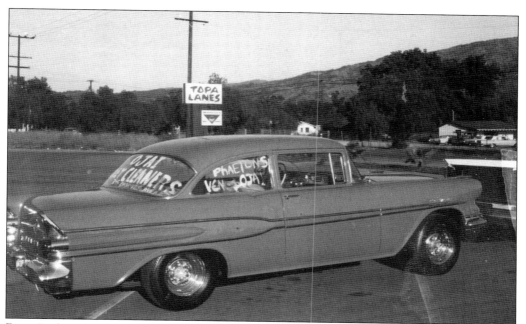

Dave Barker also owned this 1957 Pontiac Catalina. The orange two-door sedan had a stock 347-cubic-inch V-8. Barker replaced the Pontiac Jetaway Automatic. The car won a number of trophies. It is seen here in the parking lot of Topa Lanes, the local bowling alley and cruise-night destination on Ojai Avenue. (Courtesy of Dave Barker.)

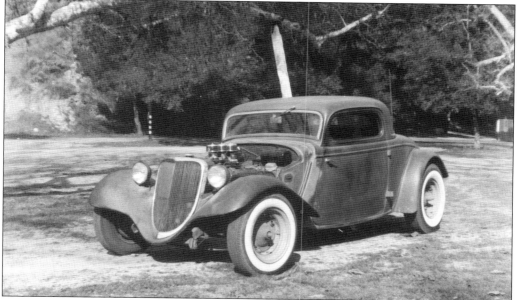

Frank Peters, a member of the Auto Aces car club of Oak View, California, owned this 1934 Ford hot rod. It is seen here at Camp Comfort Park in 1956. Completely chopped, channeled, and sectioned, the coupe was originally powered by a flathead engine hopped up at George and Duke's Speed Shop on Ventura Avenue. Peters later installed a new Ford Y-block overhead engine in its place. (Courtesy of Pete Peters.)

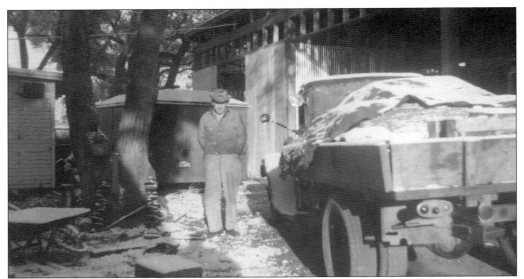

Wilson's Auto Service, at 117 West Lomita Avenue in Meiners Oaks, has been a fixture in the Ojai Valley for nearly 70 years. It was established as an automotive machine shop in 1945 by Bob Wilson (pictured above), who operated the business until 1954, when he decided to close it. Then, four years later, his brother George, a mechanic at L.N. Dietricht Automotive, decided to reopen the place as a general auto-repair service. Since then, George has run the business continuously, today specializing in American cars manufactured before 1980. His old wood-and-stucco shop is a veritable time capsule of vintage car parts and tools. As of this writing, George Wilson can still be found there every weekday, working on an engine or a set of brakes for a classic car. The above photograph shows the shop after a rare snowstorm sometime in the early 1950s. (Both, courtesy of George Wilson.)

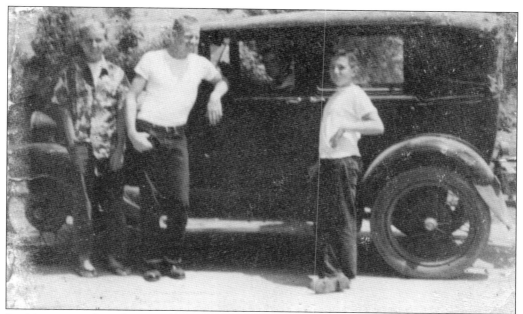

In this poor-quality photograph, Ojai resident Steve Smith sits behind the wheel of his newly acquired first car, a 1928 Ford Model A sedan. A genuine barn find, the old Ford was rescued by Smith from a ranch in the Ojai backcountry. Shown with Smith are, from left to right, Dennis Reid, Ron Reid, and Alan Benson. Smith graduated from Nordhoff High School in 1962. (Courtesy of Steve Smith.)

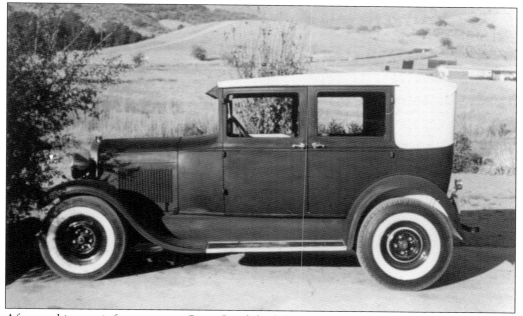

After working on it for two years, Steve Smith had the old Model A looking pretty respectable. The body, frame, and suspension have been completely rebuilt and upgraded, and the original four-banger engine was replaced with a 1948 Mercury flathead engine. Note the white vinyl top. The hot rod is pictured in Ojai's west hills, near Montana Circle. (Courtesy of Steve Smith.)

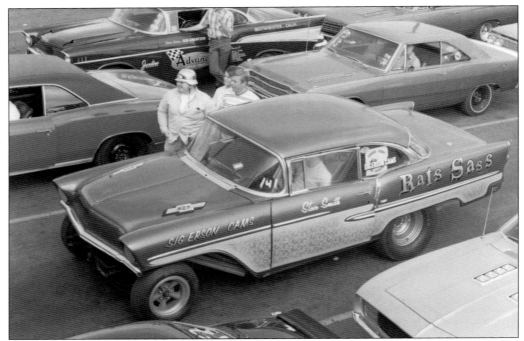

Steve Smith would later build this wild, altered wheelbase 1955 Chevrolet "Rats Sass," which he raced in elapsed-time brackets at Lions Drag Strip. The name was changed to the slightly less-vulgar version at the request of track officials. The car was steel-bodied, with a fiberglass front end. The power plant was a 427-cubic-inch Chevrolet with a four-speed transmission. (Courtesy of Steve Smith.)

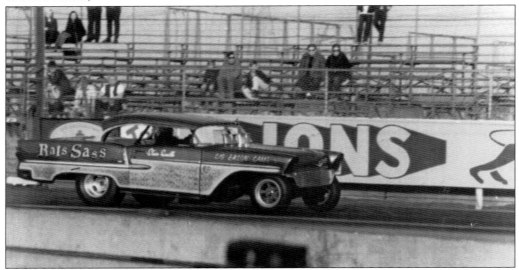

"Rats Sass" was a regular sight at Lions during the last season of the venerable drag strip, where it was popular with the spectators for its wheelie displays. Steve Smith painted the altered two-tone metallic green with gold lace stenciling on the lower part. The gold-leaf lettering was done by Jim Naylor. Smith would later sell the car to fellow Ojai resident Manuel Saenz. (Courtesy of Steve Smith.)

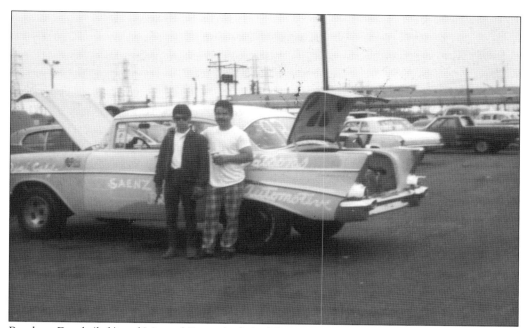

Brothers Frank (left) and Manuel Saenz (right) of Ojai are seen here at the Long Beach drag strip in 1970. The brothers specialized in Chevrolets, particularly the 1955, 1956, and 1957 "tri-five" models. Their younger brother Frank's work would become known nationally, with several of his cars appearing in magazines like *Hot Rod* and *Car Craft*. (Courtesy of Manuel Saenz.)

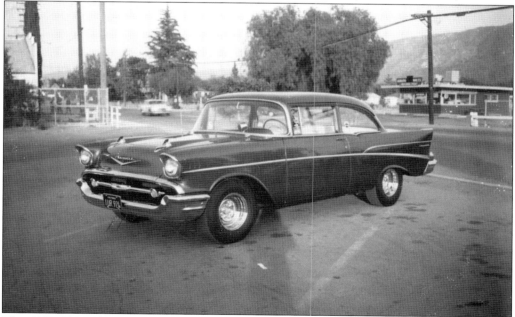

This 1957 Chevrolet 210 is an example of Manuel Saenz's excellent work. The clean model 210 two-door was painted Metallic Peacock Blue and powered by a 283 small block with dual quads and a four-speed transmission. Visible in the background at right is the Hitching Post drive-in, a popular hangout with local teens. (Courtesy of Manual Saenz.)

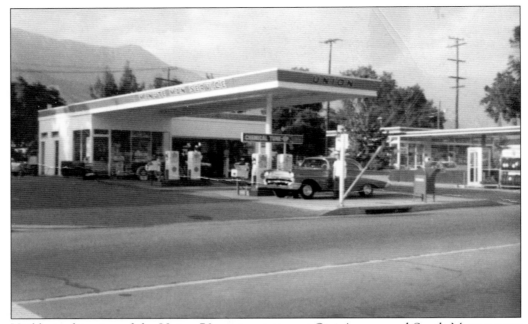

Visible in this view of the Union 76 service station at Ojai Avenue and South Montgomery Street is another of Manuel Saenz's Chevrolets, a fine 1957 Bel Air. Manuel painted it a Buick color, Frosted Metallic Blue. Ojai local Jimmy Mays can just be seen standing by the driver's door. (Courtesy of Manuel Saenz.)

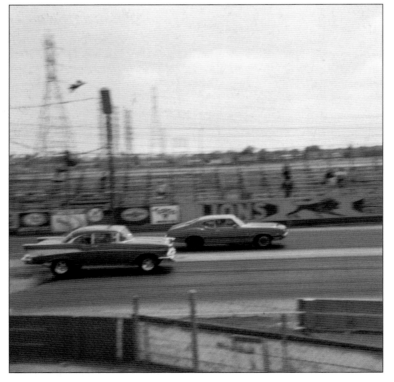

Manuel Saenz also did his time at the region's drag strips, racing in Stock class. Here at Lions Drag Strip in 1971, he is seen in a duel with an AMX Javelin (right). Saenz is driving yet another of his nicely done 1957 Bel Air coupes. Both Manuel and his brother Frank are still active in restoring vintage Chevrolets. (Courtesy of Manuel Saenz.)

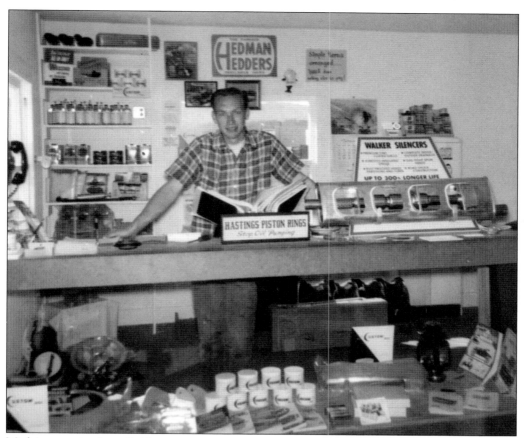

Michigan native Lary Reid moved to the area in 1956 and established Lary Reid's Speed and Sound in a small building just off Ventura Avenue in Oak View, where he installed mufflers and repaired car radios. Reid also specialized in Model T hot rods, and the little speed shop began to attract local hot-rodders and classic-car buffs. In the above photograph, Reid stands behind the counter in his store. Note the various products and accessories on display. Shown at right, he is adjusting the rocker arms of the Buick nailhead engine in his personal hot rod. Reid is standing between two unidentified, but very cool-looking, locals. (Both, courtesy of Lary Reid.)

Lary Reid was an early proponent of the "kookie" Model T hot rod. These were modeled after the hot rod driven by a hipster character named "Kookie" in the television series *77 Sunset Strip* of the late 1950s and early 1960s. The car shown in these photographs was built by Norm Grabowski. These cars involved Ford Model T roadster bodies that were usually raked up on shortened frames, equipped with a big engine, and featuring a lot of chrome and brass plating. Over time, these customs would become more elaborate and outrageous. The long, straight pipes coming out of Reid's early example are just for show, actually joining into a dual exhaust under the car. Below, Reid is parked in the lot of the Ojai Valley Inn (background), where he worked part-time as a bartender. (Both, courtesy of Lary Reid.)

Irrepressible hot rod builder and actor Norm Grabowski (left) was a friend of Lary Reid's and a frequent visitor to the shop. Like a lot of Los Angeles–area customizers, Grabowski also supplied special cars to movie studios for use in films and television. The phaeton shown here is featured in the comedy series *My Mother the Car.* At right is Grabowski's girlfriend Carolyn Romersa. (Courtesy of Lary Reid.)

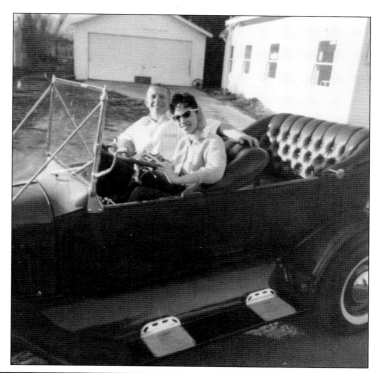

The Ford Model T Club had a large membership in the early 1960s, and this example stopped by Lary Reid's while on a club run. This photograph offers a great view of the shop. Reid is standing in the background. The Ford pickup in the left background was the shop truck. The shop building still exists as of this writing. (Courtesy of Lary Reid.)

The 1939 Ford is considered to be one of the most beautiful designs to come out of Detroit. This pair is pictured in the Mira Monte Elementary School parking lot in 1961. The coupe (left) was owned by David Miller, and his brother Mike drove the woody (right), which is still in his possession as of this writing. The coupe was sold, but it is still in the county. (Courtesy of Dwayne Bower.)

This chapter ends with a look at the lawn at Nordhoff High School on senior "ditch day" in 1961. Members of the graduating class sign yearbooks while dressed in the fashions of the day. Dwayne Bower's Packard, recently purchased from boxing camp owner "Pop" Soper, is seen at left. The cruising scene would soon begin to fade out in Ojai, but interest in hot rodding is still strong. (Courtesy of Dwayne Bower.)

Two

ACROSS THE COUNTY

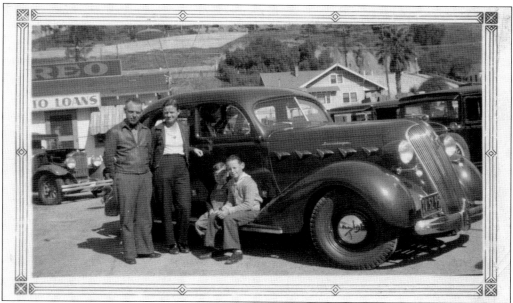

This broad view of Ventura County's motor-sports history begins in the city of San Buenaventura. The Williams family of Meiners Oaks proudly stands next to their brand-new 1937 Graham Series 120 Custom Supercharged Sedan. The big, good-looking coupe with a supercharged six-cylinder engine offered high performance at a reasonable price. The Reo car dealership, which sold the Graham make and where this photograph was taken, stood in the heart of Ventura's old town, at the corner of Main and Palm Streets. This photograph's link to racing history is the small boy seated at right on the car's running board. He is Ron Williams, who will grow up to become the fastest man in the county for a time. He set a speed record at Bonneville Salt Flats that still stands. (Courtesy of Dennis Williams.)

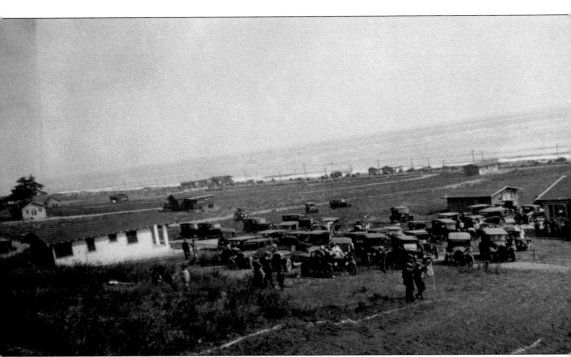

This 1925 photograph shows a hill-climb event for Ford Model Ts at La Conchita. The area was also used by the Santa Barbara Motorcycle Club and the Ventura Twin Wheelers for similar activities. The photograph appears to have been taken near the present-day intersection of Vista del Rincon Drive and Carpinteria Avenue. The group of buildings in the middle background is near where Santa Barbara Avenue joins Highway 101. Note the beginning of the course at left and the race official leaning on the marker flag. A Model T at center appears to be ready to make the climb. (Courtesy of Ed Langlo.)

The earliest car clubs in the county were the Slug Slingers and the Whistlers, followed by the Motor Monarchs in 1950. Since the clubs in Ventura had no legal places to race, they had to go afield, to strips at Goleta, Saugus, and, in the case of these photographs, Bakersfield. On a cold day around 1951, members of the Motor Monarchs prepare club member Tom Croson's Deuce roadster for a timing run. Note the pinup taped to the radiator shell in the above photograph. Croson's head is just visible behind the steering wheel. To the right of him is Dave Marquez, and then Eddie Martinez. Below, Lee Ledbetter (center left) moves over to help other club members push the roadster to the starting line. (Both, courtesy of Lee Ledbetter.)

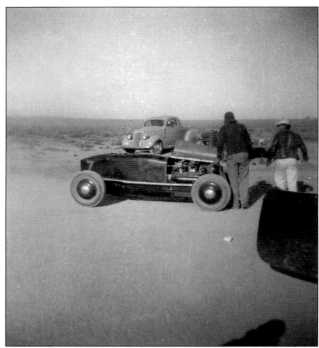

While attending a meet at Muroc Dry Lake in the late 1940s, Lee Ledbetter took this photograph of Stu Hilborn's neat, black lake racer. Hilborn, of fuel-injector fame, would soon break his back when the little streamliner lost control and flipped during a high-speed run. (Courtesy of Lee Ledbetter.)

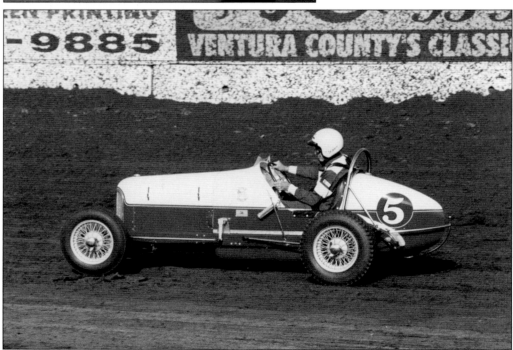

Racing legend Keith Loomis of Ojai built this 1925 Miller Indy "big racer" copy from a set of original blueprints. Seen here in 2005 doing an exhibition lap at Ventura Speedway, the four-cylinder Ford "B"–powered racer has since been used for vintage hill-climb events. (Courtesy of Keith Loomis.)

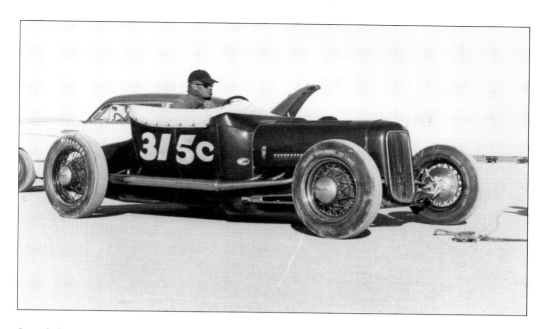

Speed-shop owner Paul Scheifer makes a very cool appearance at El Mirage Dry Lake in these photographs taken by Lee Ledbetter. Scheifer, from San Diego, obviously spared no expense in the construction of this beautiful, dark-blue lake racer. Based on a Model T, the roadster was powered by a flathead V-8 fed by twin Stromberg 97 carburetors. Note the hydraulic brakes, chromed tubular front axle, and cut-down deuce radiator shell. Note the towline, lying on the ground in the above photograph and shown attached to the front axle below. (Both, courtesy of Lee Ledbetter.)

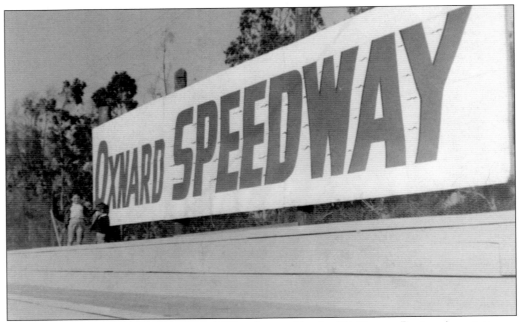

Oxnard Speedway was a track built in 1956 and owned by the Tri-County Racing Association, a group of jalopy racer owners and drivers. The nearest dirt track was the Thunderbowl, 20 miles north in Carpinteria, and the association members wanted an additional place to race that was closer to home for some of them. (Courtesy of Jim Sharpe.)

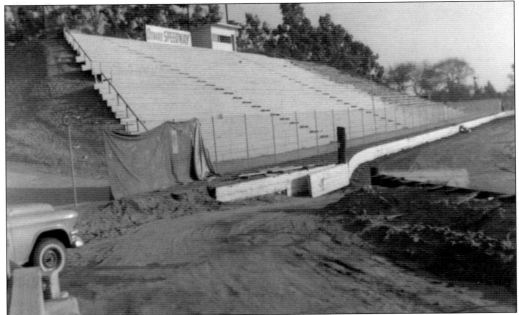

Land was acquired by the Santa Clara River, where it is crossed by US Highway 101, near Wagon Wheel Center. Association members, including Pete Gallagher, Buford Lane, Paul Lang, Jim Sharpe, and Lee Hammock, pitched in and built the track themselves. The track and grandstands are shown here under construction. (Courtesy of Jim Sharpe.)

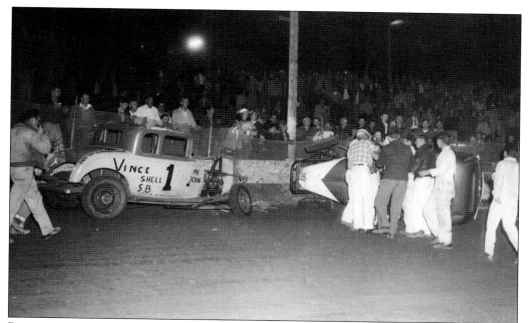

Races at Oxnard were the usual thrill-packed events that drew crowds at tracks up and down the Central Coast. Here, Paul Lang's 1934 Ford Tudor is on its side after a mix-up with a Model A coupe from Vince Shell Service in Santa Barbara. It appears that the coupe suffered some damage, too. (Courtesy of Jim Sharpe.)

Some prominent members of the Tri-Valley Racing Association gather at a club picnic at Mill Park in Santa Paula. Shown here are, from left to right, association president Randy Clowes, R. Spencer, unidentified, Merino Peri, Pete Gallagher, Buford Lane, and Paul Lang. Most members were small businessmen, tradesmen, or professionals who raced as a hobby. (Courtesy of Jim Sharpe.)

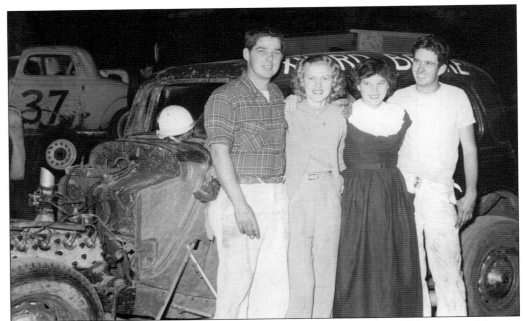

Buford Lane and Paul Lang were typical jalopy racers. Lane (left) owned a Mobil station on Ventura Avenue, and Lang (right) ran a plastering business. The two friends began racing as partners in 1949 and later drove individually for various sponsors. Lane poses with his wife, Ada May, and Lang stands with his wife, Maria. (Courtesy of Jim Sharpe.)

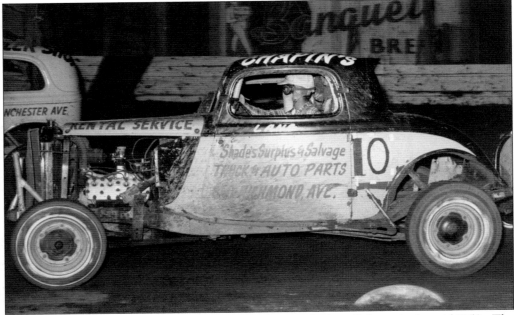

Paul Lang drove this 1934 Ford coupe for Pat Shade's Pacific Auto Salvage in the mid-1950s. The good-looking Lang was popular with the crowds attending jalopy races in those days, and he won quite a few races, too. Note the leather face shield Lang is wearing for protection. (Courtesy of Jim Sharpe.)

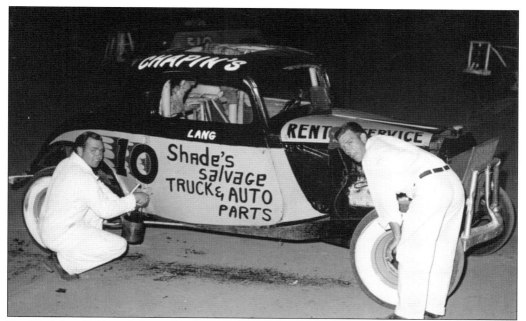

Jim McAden (left) and Gene Fox spruce up Paul Lang's jalopy prior to a race. The black-and-yellow coupe would soon be spattered with mud and bear a few battle scars. Note the early roll cage visible through the windows. The cage was fabricated from surplus oil-field pipe, and crude padding has been added to protect the driver. (Courtesy of Jim Lang.)

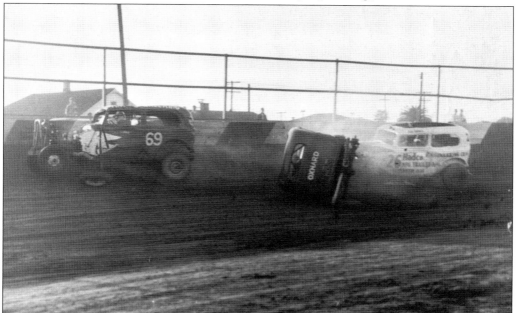

Driver protection was essential in jalopy racing, which often involved crashes. Here, Paul Lang rolls over at Culver City. Although such spills were common, serious injuries were rare. Oxnard Speedway operated for two seasons and then closed when the Bureau of Land Management bought the association out as part of a Santa Clara River restoration project. (Courtesy of Jim Sharpe.)

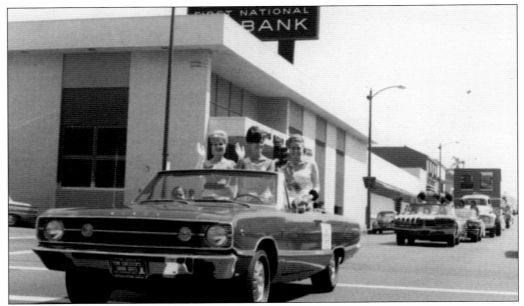

The Ventura County Fair, held every August, kicks off with a parade. Hot rods have always been included, and this and the following several photographs from 1969 depict the participation of the Ventura County Timing Association. Here, the parade queens cross the intersection of California and Main Streets. In the background is the Security Pacific Bank building, now occupied by Bank of America. (Courtesy of Jim Fain.)

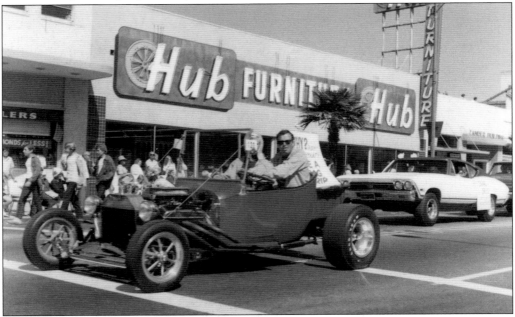

Bill Hahn, owner of a local Richfield gas station, drives his cool-looking custom T-bucket along the parade route. He is in front of the Hub Furniture store, located on the north side of Main Street between Oak and California Streets. The Hub store was part of a chain that had locations all over Southern California. (Courtesy of Jim Fain.)

Charlie Brown of Ventura proudly shows off the beautifully finished Willys gasser that he and his partners had just purchased. It is seen here as the parade moves down Main Street in the vicinity of Kalorama Street. Sadly, the metallic-green, blown Chrysler-powered coupe would be wrecked on its first outing at Irwindale Raceway. (Courtesy of Jim Fain.)

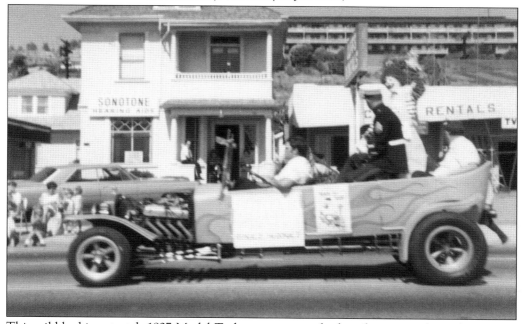

This wild-looking stretch 1927 Model T phaeton attracted a lot of attention for its lime-green flame paint job and for the US Marines recruiter and clown in the back. Visible on the ridge at upper right is a Ventura landmark, the Hawaiian Village apartment complex. The old house in the background still stands. (Courtesy of Jim Fain.)

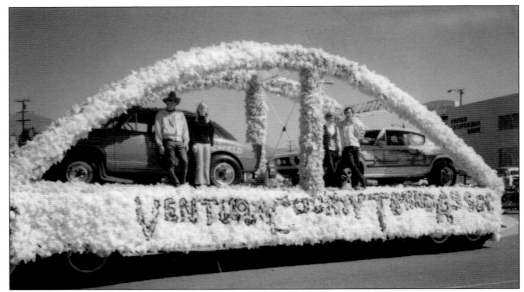

The Ventura County Timing Association (VCTA) ran this large float in the parade, in an effort to increase the club's visibility. Jim Fain is on the left, leaning against his Henry J gasser, and Ed Chamberlain is at right by his Plymouth Barracuda. Accompanying them are two unidentified cheerleaders from Ventura High School. (Courtesy of Ed Chamberlain.)

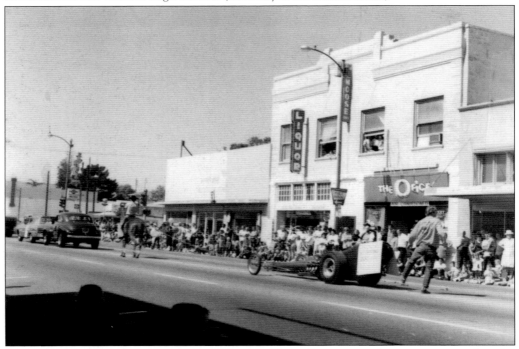

As the parade nears the intersection of Main and Palm Streets, parade goers are treated to the comical sight of a top-fuel dragster being towed by a horse. In the distance at left is the Top Hat hot dog stand, and across Palm Street is the storefront that would become the Cajun Kitchen restaurant. (Courtesy of Jim Fain.)

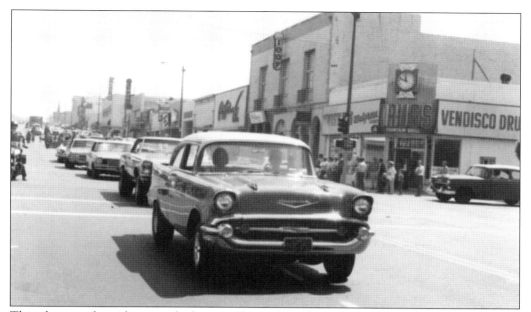

This photograph, with a view looking southeast from the intersection of California and Main Streets, shows the long line of cars stretching up Main toward midtown, with Dave Corrente's Chevy in the lead. In the right background looms the Odd Fellows Hall, and at the corner is the Vendisco drugstore. The Odd Fellows Hall remains on Main Street to this day, but the businesses have all changed. (Courtesy of Jim Fain.)

The parade turned left at the San Buenaventura Mission, moved down Figueroa Street (now partially closed), under the newly completed Highway 101 overpass, across the railroad tracks on Front Street, and wound up at the county fairgrounds at Seaside Park for a car show. This T-bucket is crossing Front Street. The mission can be seen in the distance, left of center. (Courtesy of Jim Fain.)

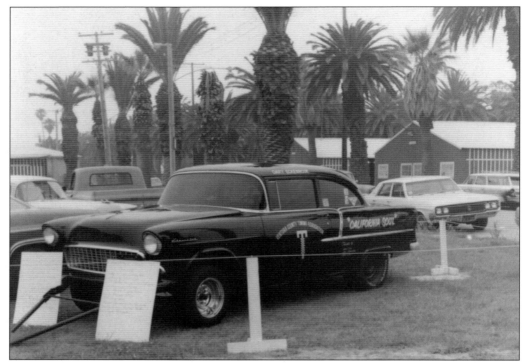

At the fairground, VCTA members had their cars on display. This is Gary Eckenrode's 1955 Chevrolet, "California Soul," which started as a street rod and was modified over time into a full-on drag racer. The beautiful black coupe was soon wrecked on the strip at Orange County International Raceway. In the background is one of the fairground's exhibition halls. (Courtesy of Jim Fain.)

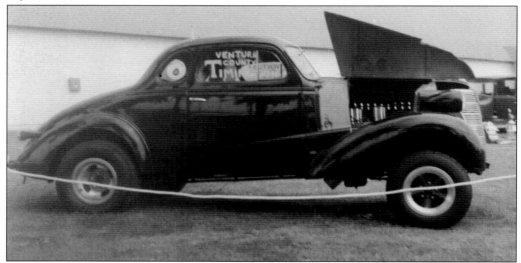

This formidable-looking 1938 Chevrolet belonged to VCTA member Larry Cunningham, who raced it as a D/Gasser. The hood is open to reveal the Hilborn injector intake stacks on the Chevy small-block engine. Note the classic mag wheels up front and the equally classic slotted aluminum wheels in the rear. (Courtesy of Jim Fain.)

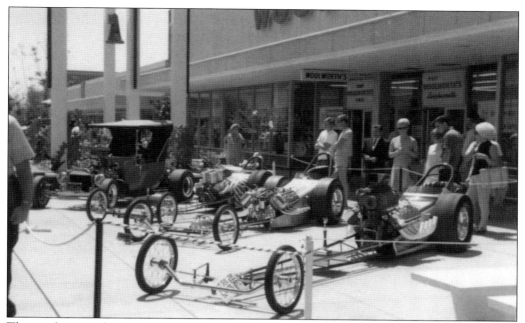

The newly opened San Buenaventura Shopping Center at Mills Road was also a venue for car shows. The mall is seen here in 1969, when it was in its open configuration. The crowd in front of the Woolworth's is admiring an assortment of locally owned drag racers. At left is a custom Model T bucket hot rod. (Courtesy of Jim Fain.)

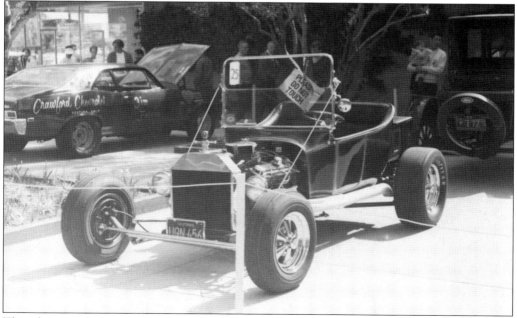

This photograph shows the variety of vehicles a visitor could expect to encounter at a car show of the era. In the foreground is a typical T-bucket (note the sawed-off pickup bed). A restored "phone booth" Model T is at right. On the left is the super-stock Chevy Nova driven by Ventura resident Jim Ferren and sponsored by Crawford Chevrolet. (Courtesy of Jim Fain.)

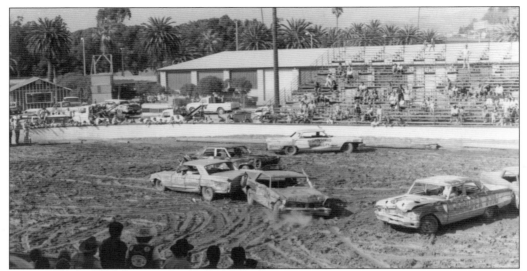

Another facet of the local motor-sports scene was figure-eight racing, more commonly known as demolition derbies. Shown here is one such competition at the Ventura County Fairgrounds. Take a large group of older, full-sized American sedans and have them race a figure-eight course on a dirt track with few rules as to driving behavior. The results were always the type of mayhem pictured here. (Courtesy of Jim Fain.)

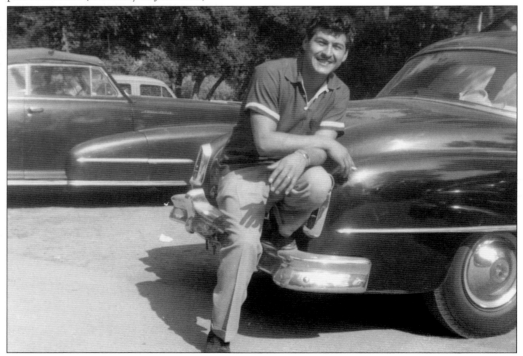

Santa Paula native Danny Flores, an honorary member of the Motor Monarchs, is seen here taking it easy at Camp Comfort. Flores was better known as Chuck Rio, saxophone player for the rock 'n' roll group the Champs and composer of their long-lasting hit record "Tequila." Flores hung out with the Monarchs and was allowed to wear club colors. (Courtesy of Wanda Jackson.)

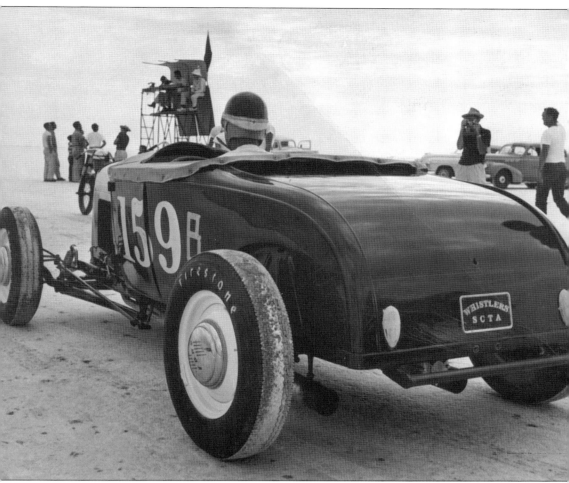

Many Ventura hot-rodders made the trip to the famed salt flats at Bonneville to test their mettle. Ron Williams, known as the fastest man in Ventura during the late 1940s and early 1950s, was a member of the old Southern California Timing Association–sanctioned car club, the Whistlers. He is seen here at Bonneville in 1954, just before his record-setting run of 159.57 miles per hour in a class B roadster. Of interest is the open timing tower in the background. (Courtesy of Dennis Williams.)

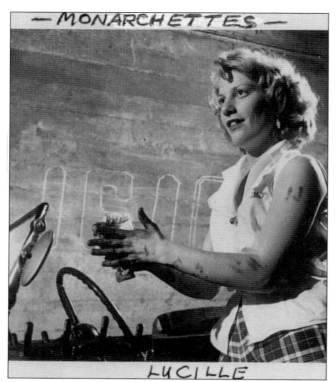

— MONARCHETTES —

LUCILLE

The Ventura motor-sports scene of the 1950s was remarkably diverse for the time. A lot of young women were just as interested in cars as the men, and this led to the establishment of the Monarchettes car club in 1956. Started in George Fraser's automotive shop class at Ventura High School, and not affiliated with the Motor Monarchs, the club later moved to the night school at Ventura College, where George Bucquet taught one of the few automotive courses offered to women in California. Club president Lucille Kenney is seen at left. The below photograph, of Bucquet's class at Ventura College, shows, from left to right, Joanne Garcia, unidentified, George Bucquet (bending over engine), Ethel Kenney, and unidentified. (Both, courtesy of C. Darryl Struth.)

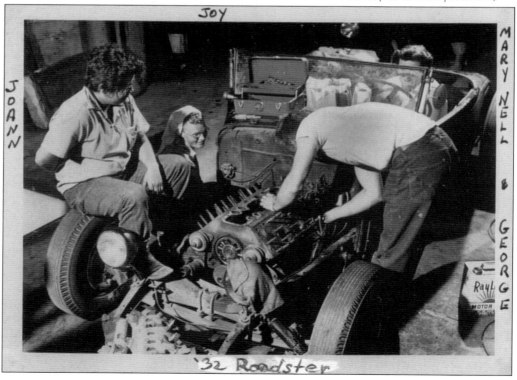

JOANN JOY MARY NELL & GEORGE

'32 Roadster

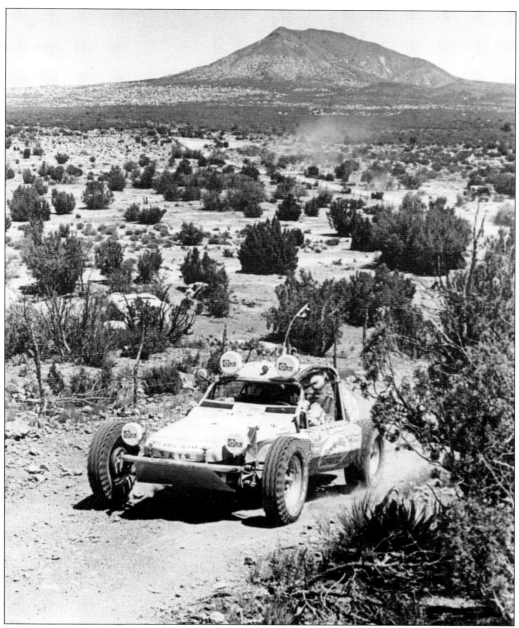

Off-road racing is a sport that has roots in Southern California, especially on the Central Coast. Whether it was dune buggies at Pismo Beach, souped-up jeeps on the fire roads, or stripped-down Volkswagens in the desert, the motor-sports enthusiasts of California naturally took to off-roading. The mid-1960s saw the beginnings of professional off-road racing, with the Mint 400 and Baja 1000 races garnering large amounts of national media attention. A thriving industry manufacturing parts and equipment for off-road vehicles sprang up, and Ventura County became a center for technical innovation. Here, Santa Paula's Dave Marquez drives his custom-designed off-road racer "Pancho Villa Express" through the beautiful landscape of the Mexican desert in the Baja 300. (Courtesy of Mark Mendenhall.)

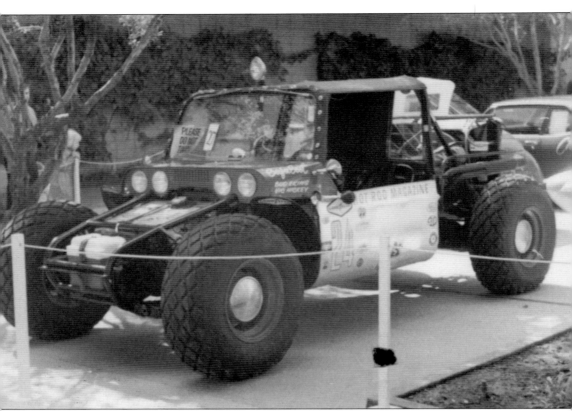

This is one of the most technically advanced off-road vehicles ever built, Vic Hickey's "Baja Boot." Hickey, a California mechanic, designer, and producer of off-road racing products, was hired by General Motors in 1959 to work on special projects, including the lunar rover for NASA and what would become the High Mobility Multipurpose Wheeled Vehicle (HMMWV), or Humvee. Vic built the first of two mid-engine Boots at GM's design center in Detroit, and it was later raced by actor Steve McQueen and legendary stuntman Bud Ekins. After overcoming the inevitable teething problems of such an advanced design, the Boots went on to successful careers in racing. Shown here is "Boot 2," which was built in Ventura after Hickey moved his off-road business there in 1969. It featured an Oldsmobile engine, Turbo 400 transmission, Hurst shifter, and a strong tubular frame. Both Boots have survived and are in private collections. (Courtesy of Jim Fain.)

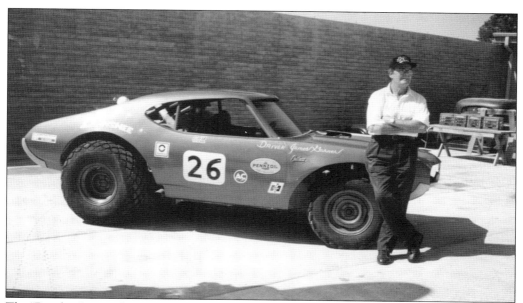

The "Banshee" is another example of Vic Hickey's talents. Following the Boot's design, the Banshee had a tube frame and mid-engine configuration. A shortened fiberglass Oldsmobile Cutlass body by George Barris was mounted on the frame, leading *Hot Rod* magazine to describe the car as an "off-road funny car." It would be driven by movie and television actor James Garner (pictured) in races in the late 1960s and early 1970s. The Banshee was powered by a 480-horsepower, 455-cubic-inch Oldsmobile engine attached to a Turbo 400 transmission and had a top speed of over 140 miles per hour. Run by Garner in races like the Mint 400 and the Riverside Grand Prix, and wrecked twice, the car would be taken over by Mickey Thompson, who raced it with little success until 1972. The "Banshee" has been restored and is under private ownership. (Both, courtesy of Mark Mendenhall.)

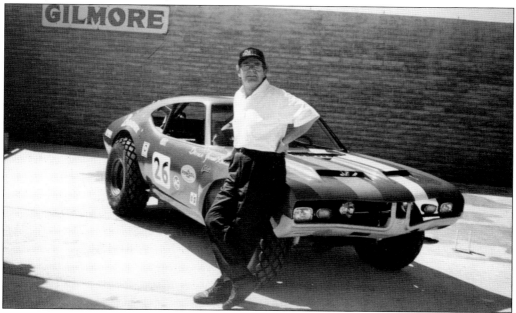

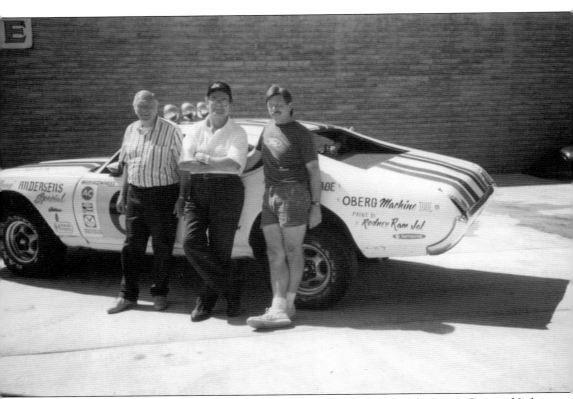

Prior to the "Banshee," Vic Hickey built this off-road Oldsmobile 442 for James Garner. Hickey took a stock, 1970 full-bodied passenger car and beefed up the frame in critical spots with one-eighth-inch steel plates. Skid plates were installed under the engine and transmission, and the suspension was strengthened by doubling the shock absorbers. All four wheels featured disc brakes. The engine was a stock Oldsmobile 350, and the transmission was a Turbo Hydramatic, also stock. The stripped-out interior contained a NASCAR-type full roll cage and a full set of Stewart-Warner gauges on a sheet-aluminum dashboard. Garner raced the car with codriver Dave Maurer. While the Oldsmobile did not win many races, it was competitive. Shown here are, from left to right, Jack Mendenhall, Garner, and Mark Mendenhall. (Courtesy of Mark Mendenhall.)

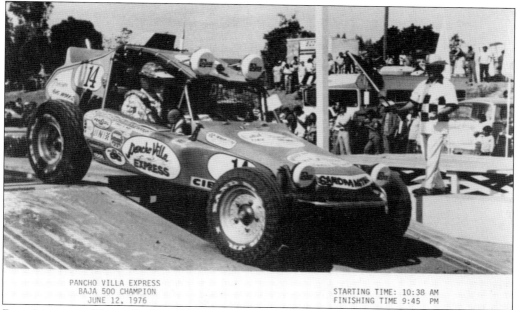

PANCHO VILLA EXPRESS
BAJA 500 CHAMPION
JUNE 12, 1976

STARTING TIME: 10:38 AM
FINISHING TIME 9:45 PM

Dave Marquez of Santa Paula and his crew built this off-road racer, the "Pancho Villa Express." Based on a Sandmaster frame with a special fiberglass body designed and fabricated by Sam Foose, the buggy was raced in two classes. For Class 2, a 2,180-cubic-centimeter Sandmaster engine was used. When racing in Class 10, the engine was changed out to a 1,200-cc unit by Precision Bug Works. Sig Erson cams and Berge roller cranks were used on both engines. The crew sat on Porsche seats, and the car was equipped with a CB radio for communicating with the support team. Marquez and his team were very competitive, successfully campaigning the "Express" in the 1974 Baja 300, the 1976 Baja 500, the 1978 Mint 400, and numerous other races in the 1970s. (Both, courtesy of Mark Mendenhall.)

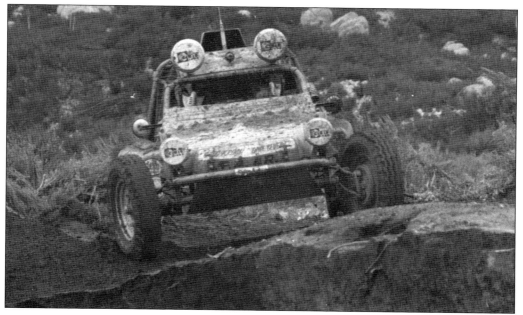

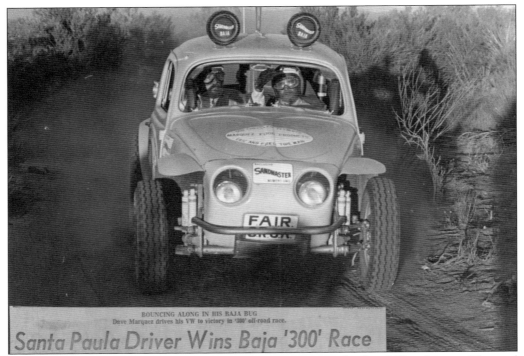

BOUNCING ALONG IN HIS BAJA BUG
Dave Marquez drives his VW to victory in '300' off-road race.

Santa Paula Driver Wins Baja '300' Race

Dave Marquez also raced Baja Bugs with some success, winning the Baja 300 in this one. He raced both cars at events like the Baja and Mint, showing up with a convoy of trucks and trailers, plus a full crew attired in his race colors of Day-Glo orange and white. (Courtesy of Mark Mendenhall.)

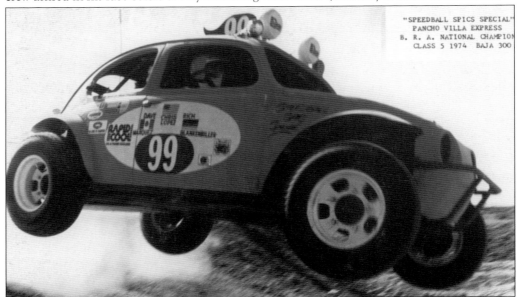

"SPEEDBALL SPICS SPECIAL"
PANCHO VILLA EXPRESS
B. R. A. NATIONAL CHAMPION
CLASS 5 1974 BAJA 300

Dave Marquez was a major figure in Ventura County motor sports for many years. Holding over 20 national or track records, he first made his mark as a drag racer in the early and mid-1950s, turned his attention to custom cars for many years, and then became heavily involved in off-road racing starting in the mid-1960s. (Courtesy of Mark Mendenhall.)

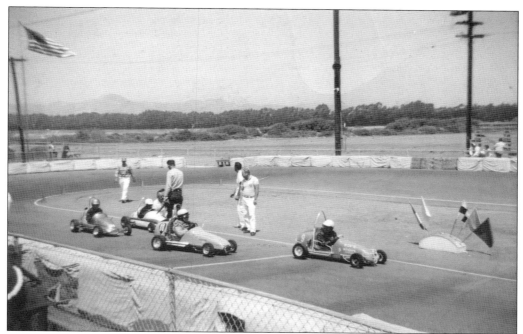

The sport of quarter-scale midget racing was very popular with Ventura's younger set in the late 1950s and into the 1960s. This photograph shows a race in progress at the track in the Pierpont district, in an area now completely built over. (Courtesy of Mike Hart.)

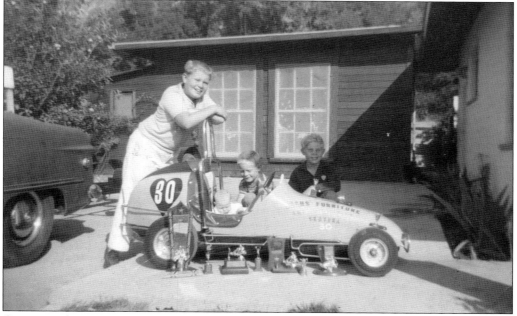

Quarter-scale racing was a good family-oriented sport, as seen in this photograph of the Hart brothers, taken in their parent's driveway in Oak View. Quarter-scale midgets were fully functional miniature race cars capable of reaching hair-raising speeds. They were built by serious manufactures, like Kustom-Kraft of Glendale, California. (Courtesy of Mike Hart.)

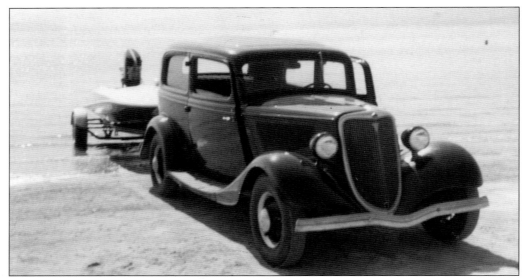

Speedboats have been popular with a large faction of county hot-rodders for many years. The damming of several rivers in the region in the 1950s created large reservoirs for drinking water that were also used for recreational pursuits, like fishing and boating. Dennis Reid's 1934 Ford two-door is ready to launch his Mercury-powered speedboat at Lake Elsinore in the early 1960s. The Ford was a restored stock version, rather than a hot rod. A fellow remembered only as "Willy Goodguy," who worked out of the garage of his home on Shady Lane in Ojai, did the upholstery. (Courtesy of Dave Barker.)

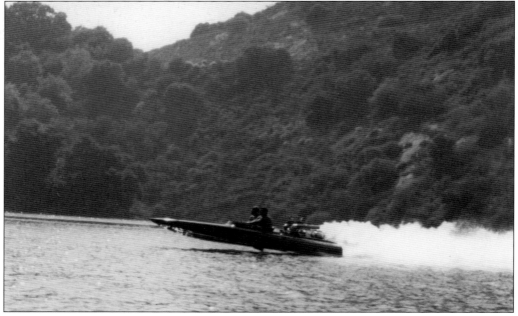

Early speedboats were large, wooden-hulled affairs often powered by 12-cylinder aircraft engines, like war-surplus Libertys and Allisons. As technology evolved, the hulls were made from lightweight fiberglass, and the boats were powered by marine V-8 engines. Here, Ernie Sawyer "rides the skeg" at Ventura County's Lake Casitas. (Courtesy of Ernie Sawyer.)

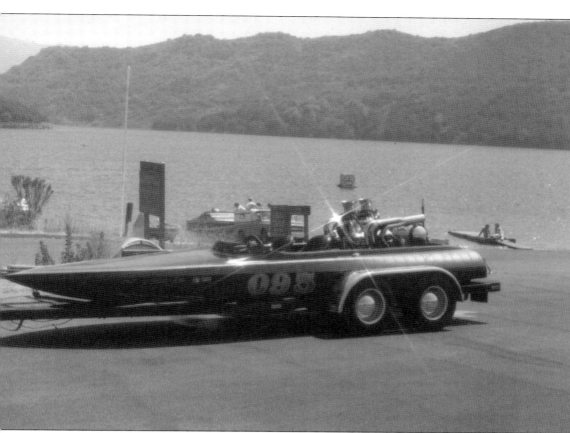

Ernie Sawyer's 18-foot fiberglass Hondo is pictured on its trailer at the Lake Casitas boat ramp. It was propelled by a massive 482-cubic-inch Chevrolet producing 850 horsepower. Sawyer was able to hit 124 miles per hour in a quarter mile at Ski-Land, the well-known drag boat "strip" in nearby Perris, California. (Courtesy of Ernie Sawyer.)

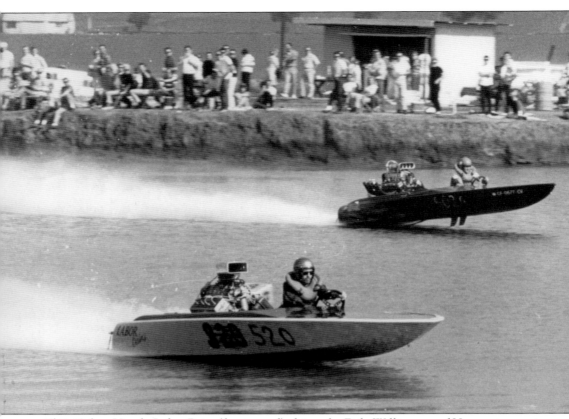

This 18-foot Hondo *Labor Pains* (foreground), driven by Dale Williamson of Hemet, is seen in a duel with another boat at Ski-Land Water Park in Perris. Dave Stoll of Bardsdale Ranch built the big, 461-cubic-inch Pontiac engine, fitting it with a Mickey Thompson Hemi-head conversion kit and a GMC blower. Ski-Land was a purpose-built drag boat course and water park in the desert east of Ventura County at Perris. The park ran for several seasons during the heyday of drag boating in the late 1960s and the 1970s and still remains, although it is now waterless. (Courtesy of Dave Stoll.)

Three

TWIN WHEELING

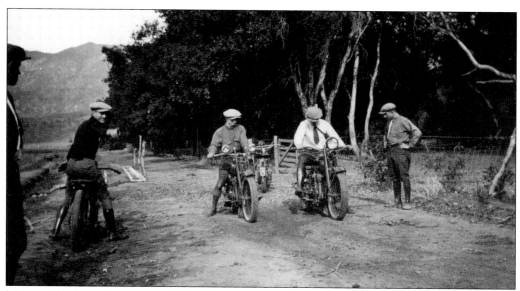

Motorcycles have been a part of the Ventura scene since the early 1900s. The first club in the county was the Ventura Twin Wheelers, established in 1923 and lasting until the 1960s. In this 1925 photograph, two motorcyclists prepare for a race down Signal Road in the Ojai Valley. The camera is facing roughly north-northeast, with Nordhoff Peak visible in the left background. The bikes facing the camera appear to be new Harley-Davidson JD models, one of which has been customized with a nonstandard headlight configuration. Note the early riding attire of high boots, jodhpurs, and neckties. (Courtesy of Ed Langlo.)

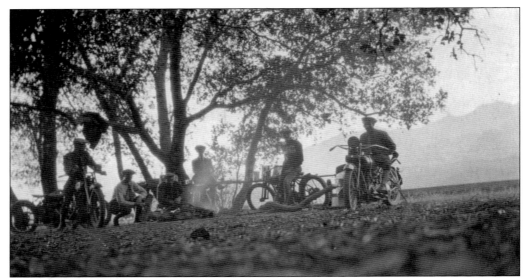

The scenic back roads of the Ojai Valley have long been popular with motorcycle clubs from all over the area. Here, members of the Santa Barbara Motorcycle Club gather around a campfire beneath the oaks and sycamores of Meiners Oaks. (Courtesy of Ed Langlo.)

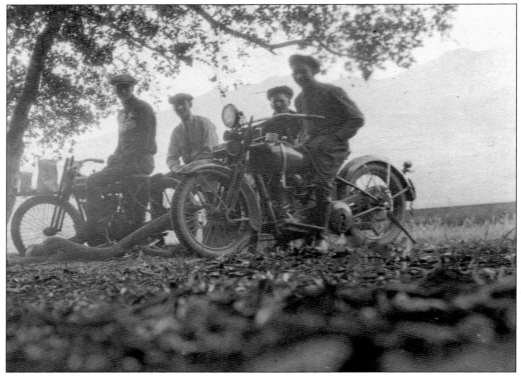

This young man sits proudly on his new Harley-Davidson JD while enjoying the scenery at Meiners Oaks. The 74-cubic-inch JD model was Harley's top-of-the-line motorcycle and possessed a lot of power in a lightweight frame. A fellow enthusiast in a Harley-Davidson turtleneck sweater looks on at left. (Courtesy of Ed Langlo.)

Dave Lewis moved to Ojai from Los Angeles in the mid-1950s. An avid motorcyclist, Lewis attended race meets all over Southern California with his friends. Here, he sits astride what looks like a 1939 Triumph Trophy that has been fitted with telescopic front forks. Note the long, aftermarket exhaust pipe and knobby tires. (Courtesy of Brian Lewis.)

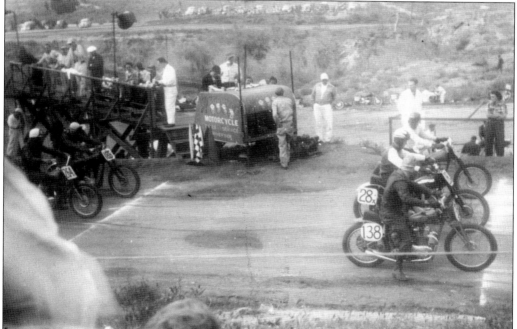

Dave Lewis frequently raced Glen Helen Raceway in San Bernardino, which was and still is a big track for motocross and most other forms of off-road motorcycle racing. The bike numbered 138 in the front looks like a 1939 Matchless G9 twin. Note the soft leather flying helmet and goggles on the rider. The other bikes appear to be English makes, mostly Triumphs. (Courtesy of Brian Lewis.)

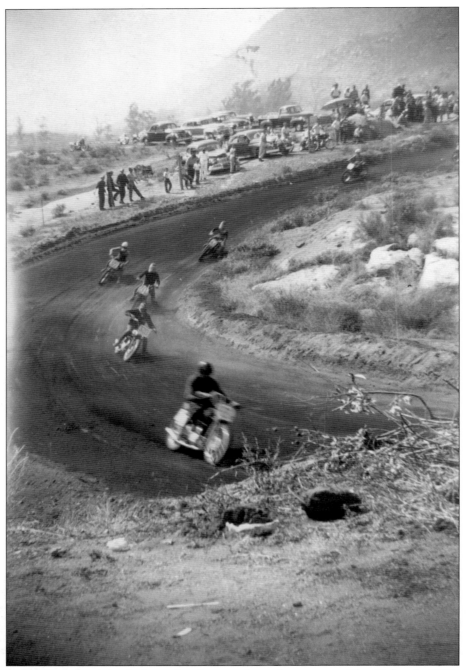

In this view, Dave Lewis leads the pack as he tears down the course at Glen Helen. In 1949, when this photograph was taken, races like this were strictly the realm of large four-stroke motorcycles like Harley-Davidson, Indian, Norton, and Triumph. The track appears to have been oiled to cut down on dust. Raceways in the 1940s and 1950s often let the spectators get right up to the tracks, as seen here, and clouds of dust obscured everybody's views, including the riders. As at all of the early racetracks, safety was not yet a big consideration. (Courtesy of Brian Lewis.)

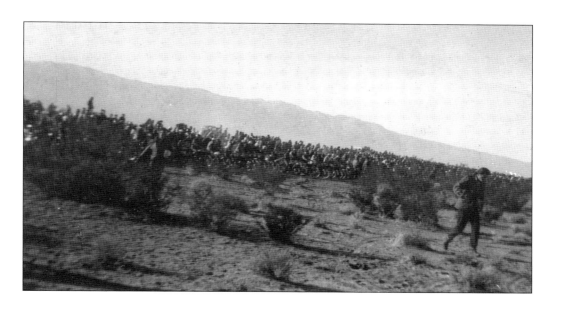

The small community of Pear Blossom, in the Mojave Desert a few hours east of Ventura, was the site of cross-country races that sometimes drew hundreds of riders, as can be seen in these amazing photographs. Going distances of anywhere from 50 to 500 miles, the riders would charge along courses marked by smoke bombs. In the above photograph, the line of waiting riders stretches into the distance as race officials prepare to start the run. Below, the photographer has turned in the opposite direction to show the scene after the race has begun. The white spots visible just below the horizon are the riders. (Both, courtesy of Brian Lewis.)

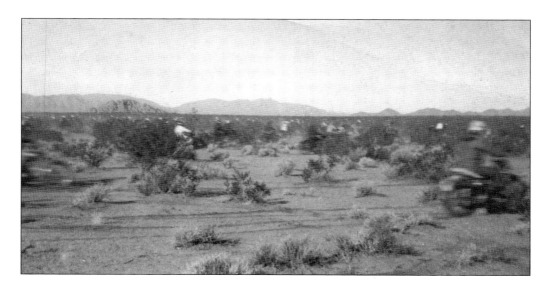

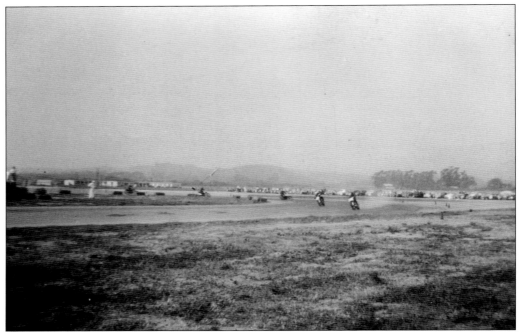

Dave Lewis also participated in what is known as TT racing. Tourist Trophy races originated on Britain's Isle of Man in 1905, making it one of the oldest motorcycle sports. In the 1950s, TT races were usually held on closed courses with laps of up to 40 miles in size and consisting in a variety of road conditions. The riders competed for best time. These two photographs were taken at a track somewhere in Southern California, possibly on a former military base. Above, Lewis can be seen at left as he comes around the curve on the inside. Below, he speeds past the camera. (Both, courtesy of Brian Lewis.)

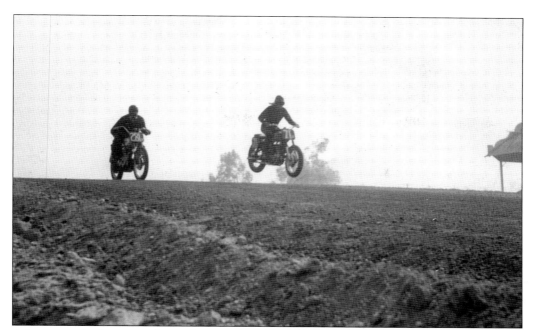

After a near-fatal motorcycle accident in which Dave Lewis broke his pelvis and most of his ribs, he was put in a cast covering almost his full body and had to undergo a long convalescence. After recovering, Lewis went right back to racing. He is seen here at right in his first post-accident race at a Los Angeles area track in 1954. (Courtesy of Brian Lewis.)

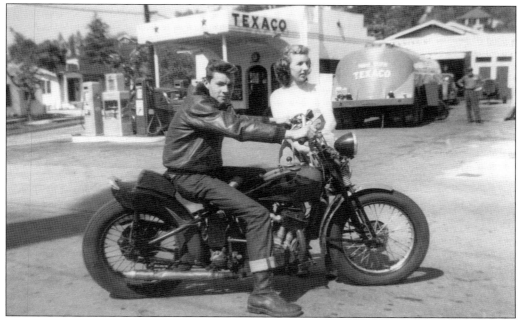

George Langas sits astride his Harley VL as a girlfriend looks on. Langas has bobbed the rear fender and added a pillion seat, and he replaced the front fender with what looks like one from a Triumph. Standard attire for motorcyclists in the late 1940s consisted of Levi's, a leather jacket, and war-surplus Army boots. (Courtesy of Brian Lewis.)

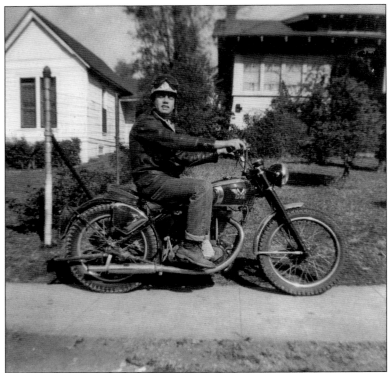

Shown here on a beautiful Matchless 500-cubic-centimeter single is Marshall Ashby. Set up for both street and dirt roads, these big bikes were often called "Scramblers." The chromed cover on the frame was the tool kit, and to the right is the oil tank for the dry-sump, four-stroke engine. (Courtesy of Brian Lewis.)

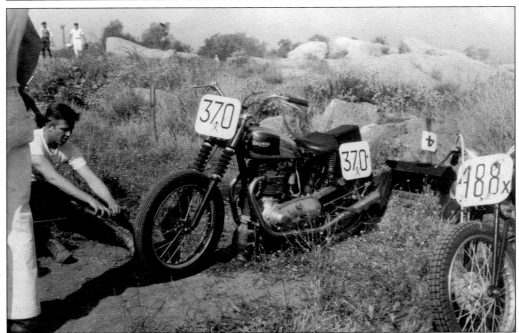

Here is a nice shot of a Triumph TR5 Trophy 500-cubic-centimeter twin from 1954. Its young rider (left) is lacing up his boots in preparation for a TT race. The front forks have been modified with a set of nonfactory rubber dust boots. (Courtesy of Brian Lewis.)

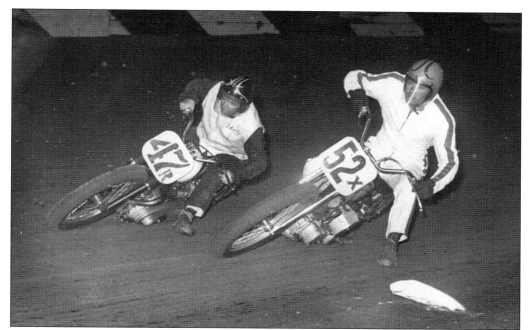

Flat-track racing was another popular sport in the region. Frequently held on the banked courses of jalopy tracks, the spectacle of brakeless motorcycles racing around a dirt oval was something to see. Above, Dwayne Keeter (right) enters a turn at Ascot Raceway on a 1953 Indian Chief. The highly modified Chief was built by Ojai resident Lee Stanley, pictured below. A specialist on Indian motorcycles and a prolific builder of flat-track bikes, Stanley also operated a paint shop on Ventura Avenue. (Both, courtesy of Dave Barker.)

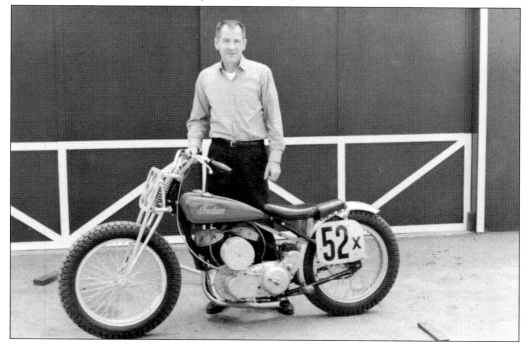

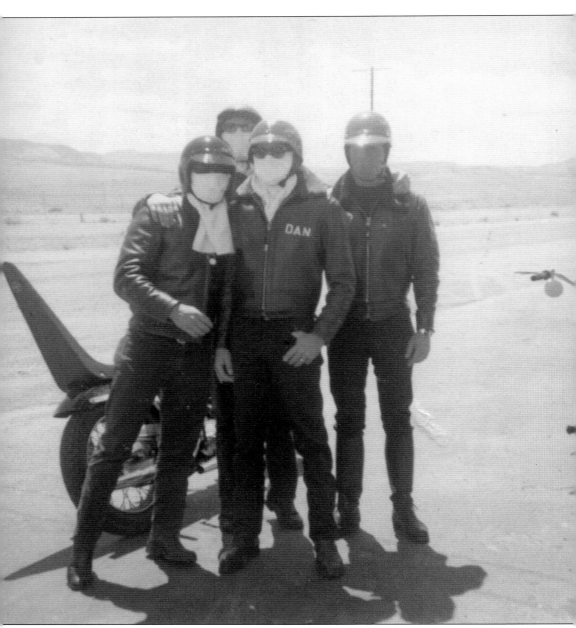

In 1966, a group of motorcycle enthusiasts from the Ventura area got together and formed the Los Borrachos Motorcycle Club. Los Borrachos was not an "outlaw" club, but rather a social one that got together for runs and other activities. In later years, many of the club members would go on to become successful businessmen and upstanding members of the community. In this photograph, taken during a dust storm in the high desert, are, from left to right, Marlene Spencer, unidentified, Danny Spencer, and C. Darryl Struth. (Courtesy of C. Darryl Struth.)

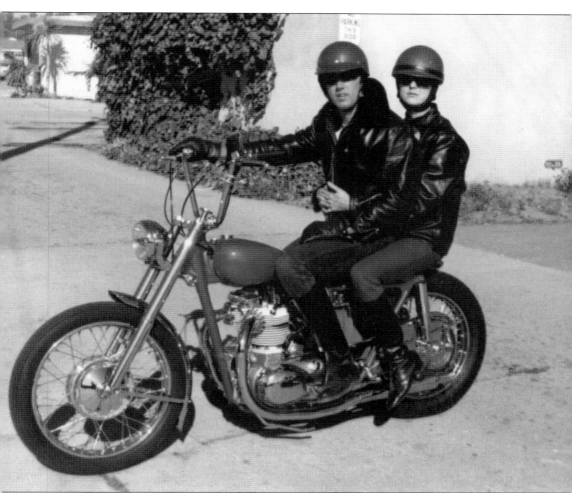

C. Darryl Struth of the Los Borrachos and his first wife, Wanda Sue, pose on their custom 1959 Triumph 650 Bonneville. Triumph motorcycles were considered the faster alternative to Harley-Davidsons in the days before the mass importation of Japanese bikes. This one sports a custom paint job. Note the "ape hanger" handlebars. Another favorite aftermarket addition in the 1960s was the "sissy bar," intended to keep the bike's passenger from falling off. (Courtesy of C. Darryl Struth.)

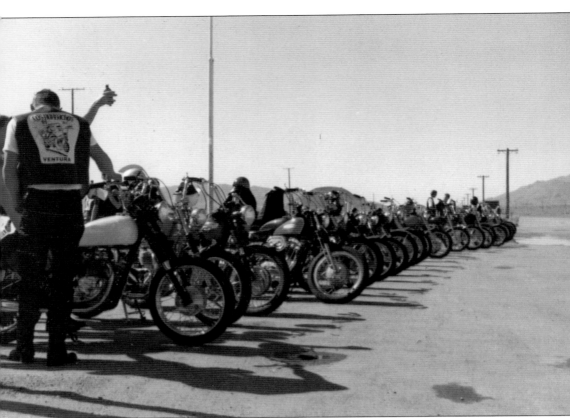

This is a Los Borrachos club ride to the nearby desert resort town of Lone Pine, California, a frequent destination for motorcycle club runs. Triumph motorcycles were the favorite of the club members, although there were several Harley-Davidsons in the club, too. Note the Los Borrachos "colors" on the individual at far left and the cooling beverage being hoisted in the air, in true biker fashion. (Courtesy of C. Darryl Struth.)

Four

COUNTY CUSTOMS

The art of car customizing—restyling a production car body to suit the personal tastes of the owner—was especially popular during the golden age of hot rodding. Ventura County residents were no exception, pulling it off with quite a bit of style. While some great-looking customs were built in the county, locals had no problem acquiring cars produced by some of the most famous names in the business. This fine 1942 Ford coupe, owned by Doug Adamson of the Motor Monarchs, was built by legendary customizer Sam Foose of Santa Barbara. One of Foose's earliest customs, it was his personal car until he sold it to Adamson. Note the way Foose decked the trunk lid and how the frenched taillights cut into the fender. (Courtesy of Sam Foose.)

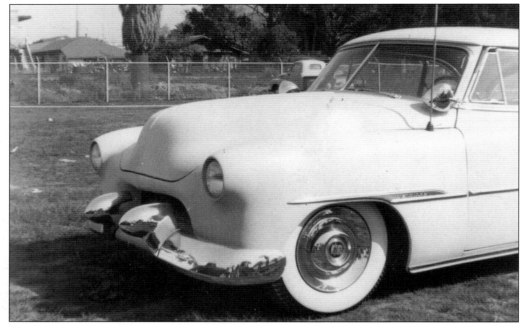

This 1951 Chevrolet Bel Air sport coupe hardtop, owned by Howard Clarkson and built with help from fellow members of the Motor Monarchs, is seen at the 1953 Ventura County Fair. Painted pale blue, the body has been channeled three inches, and the front has been nosed and frenched. The bumpers and hubcaps are Cadillac units, and a pair of Appleton spotlights sits beneath the windshield. The taillights came from a 1953 Lincoln. Note the twin exhaust pipes exiting from the bumper. All body seams were welded and filled with lead, which was the custom at the time. Clarkson would continue to develop the car's styling over the years, and it is featured in an issue of Car Craft magazine. (Both, courtesy of Pete Peters.)

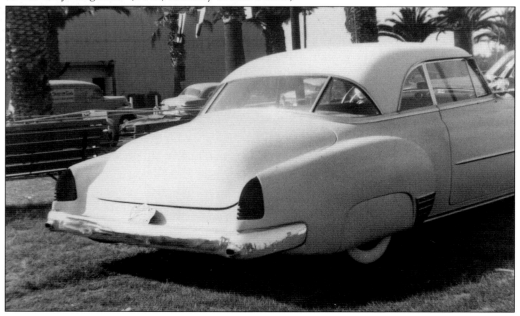

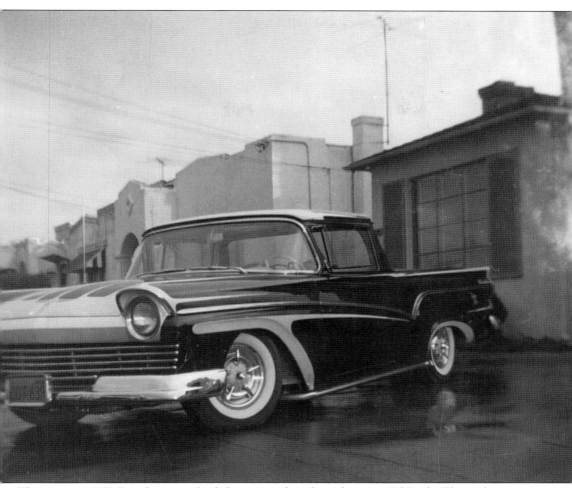

This custom 1957 Ranchero was built by none other than the great Ed Roth. The pickup was new when Roth customized it, and it was almost immediately taken as a trade-in by Motor-Mart of Ventura. It was purchased in 1958 by Ventura resident Bob Carter for $2,900, a lot of money in those days. The Ranchero was painted a color called Motorama Purple, and the scallops around the wheel wells and on the hood were done in pearl white with a lavender undercoat. (Courtesy of Bob Carter.)

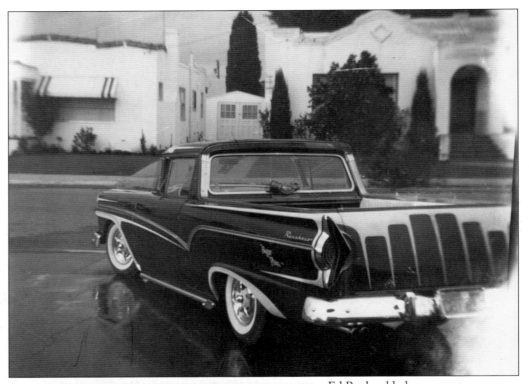

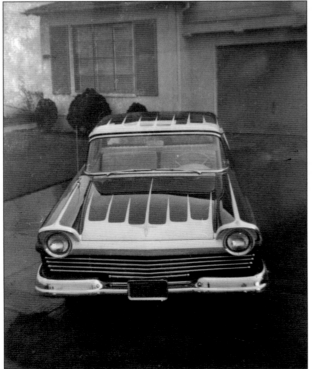

Ed Roth added some custom touches, like nosing, decking, and shaving the body. Chrome bars have replaced the grill. Note the lake pipes and spinner hubcaps. Edsel units were used as the taillights. The legend visible above the rear wheel, "Sugar Plum," was added by the car's original owner. The custom was entered in car shows during the 1958 season in Southern California and the San Francisco Bay Area. (Both, courtesy of Bob Carter.)

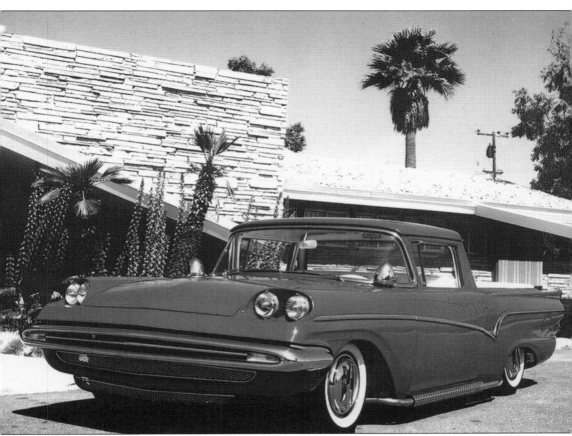

After a very successful first season with his custom, Bob Carter, who had moved to Hayward, California, had to do something really radical in order to make a splash in the next season's shows. He asked Red Johnston of Oakland, California, to refresh the front bodywork, and the result was this radical restyling. Noted Bay Area customizer Joe Bailon mixed and sprayed the candy-apple maroon with white pearl undercoat paint. (Courtesy of Bob Carter.)

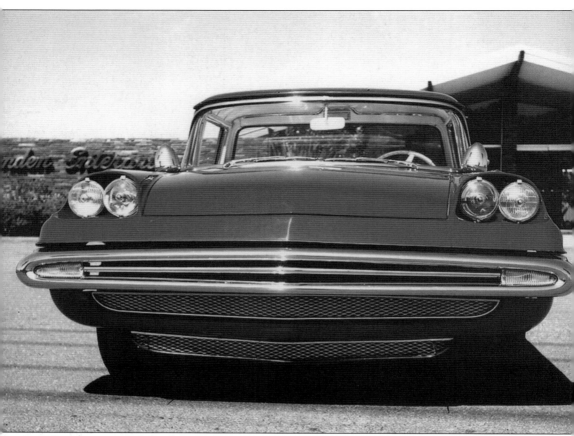

This photograph shows how Red Johnston fitted a 1957 DeSoto front grill bar into the Ranchero's front end. Note the hooded quad headlights and the two grills stacked under the center bar. The pickup was also fitted with that staple of all custom cars, dual spotlights. Carter later loaned the car to friend George Barris as part of a touring custom car show. When Ford Motor Company stylists viewed the car, they approached Carter and made him a very generous offer to buy it. Carter accepted, and Ford exhibited the car at the national Motorama shows. Design elements of Carter's custom appeared in later Ford products. (Courtesy of Bob Carter.)

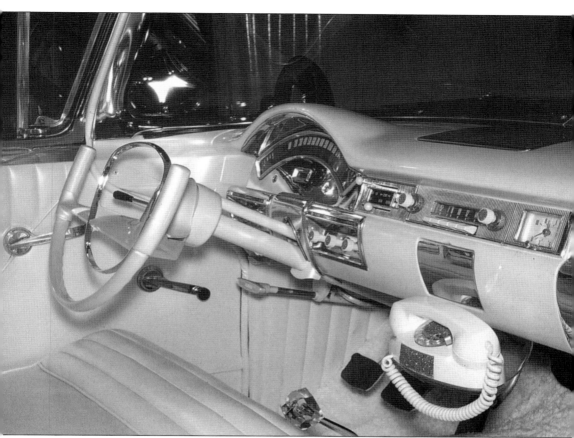

This is the well-appointed interior of Bob Carter's Ranchero, now known as the "Royal Gem."
It was upholstered in white pearl tuck-and-roll vinyl, and the dashboard was painted white pearl
with chrome accessories. The steering wheel was taken from a 1957 Plymouth. Carter sawed the
top off, giving it a very modernistic look. The telephone is nonfunctional, as were most "luxury"
additions, like telephones and televisions, in custom cars of the era. (Courtesy of Bob Carter.)

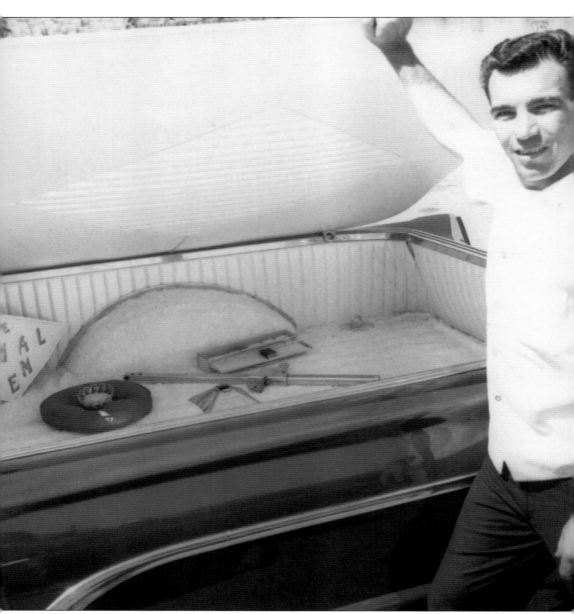

Bob Carter shows off the Royal Gem's upholstered bed. A Ventura native, Carter graduated from Ventura High School in 1957 and was a member of the Coachmen car club. After high school, he went to work as a service technician for SEAT, a Spanish car make being sold in the Ventura area at the time. He would soon move north to Hayward, California, as a technician with the California National Guard on the Nike air defense missile system. He went on to become a helicopter pilot for the Army and then had a successful career as a salesman of both helicopters and business jets. (Courtesy of Bob Carter.)

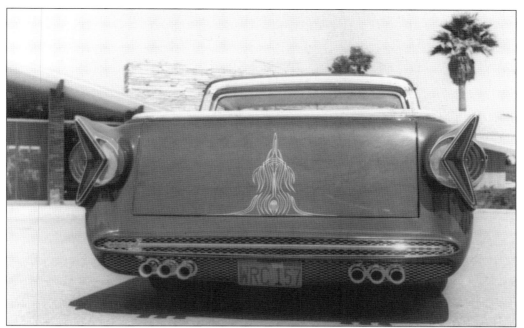

This is a rear view of the Royal Gem. The Edsel taillights have remained, but the rear underpan has been extensively restyled to mimic the front end. Note the six exhaust outlets and the very cool, late-1950s-style pinstriping on the tailgate. Customs like Bob Carter's represented the pinnacle of the art of car customizing and have no equal in today's scene. (Courtesy of Bob Carter.)

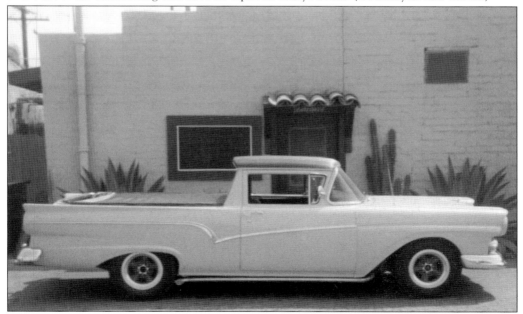

This is another take on the Ford Ranchero, from Richard Martinez of the Motor Monarchs. The car is parked at the Casa Martinez restaurant on Meta Street. Martinez did the very attractive custom grillwork on this car, which he used as his push/tow truck in drag races. (Courtesy of Richard Martinez.)

This cool coupe was called the "Buford," as it was a customized 1947 Ford Club coupe powered by an early Buick overhead V-8. It was built by members of the Kustomeers car club and sold to C. Darryl Struth of the Motor Monarchs, who in turn sold it to Bob Carter, of the Coachmen. As with most customs and hot rods, the car went through many owners before finally disappearing. Note the egg-crate front grill, taken from a 1955 Chevrolet. (Both, courtesy of Bob Carter.)

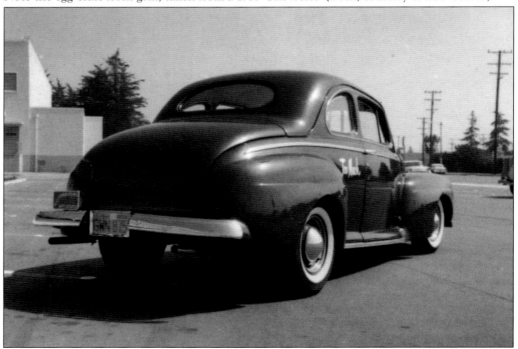

This clean, elegant custom 1949 Chevrolet coupe showed up at Saugus drag strip in 1953, where it was photographed by Lee Ledbetter. It is nosed and decked, with frenched headlights. All of the chrome trim has been shaved, except for a bit ahead of the rear fender, below the doors, and the line around the rear window. (Courtesy of Lee Ledbetter.)

Bob Richardson of Santa Paula photographed this wild custom 1957 Ford Thunderbird while attending the 1962 NHRA Nationals at Indianapolis. The car is painted candy-apple red with gold trim. The front grill and headlights have been extensively reworked, and a set of rather lethal nerf bars have been added as bumpers. (Courtesy of Bob Richardson.)

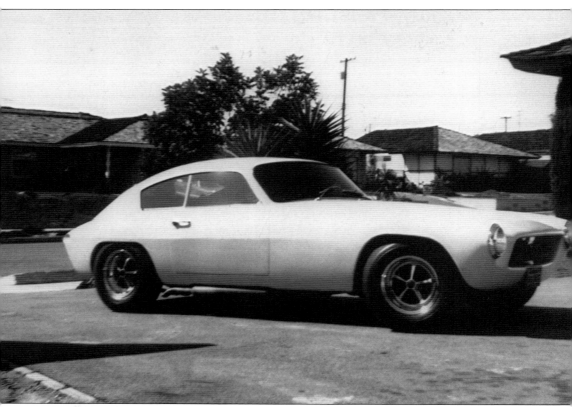

This beauty is the Victress C-3 coupe, a fiberglass kit car built in 1953 by Ventura resident Paul Kiunke. He liked the looks of the exotic coupe after seeing it in a magazine advertisement. After visiting the North Hollywood shop where the marque was made and talking to its creator, Boyce "Doc" Smith, Kiunke was convinced that he could complete an example. The styling of the Victress was quite ahead of its time for 1953, looking like a cross between an early-1970s Chevrolet Camaro and any number of late-1950s Italian sports coupes. (Courtesy of Paul Kiunke.)

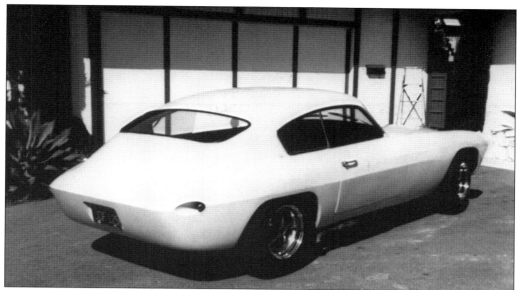

As no actual plans existed, Paul Kiunke worked with rough sketches and photographs of the few previous builds. Starting with a modified 1934 Ford frame, he used parts from a variety of manufacturers, including Nash, MG, and Chevrolet. The car was powered by a 250-horsepower, 283-cubic-inch Chevrolet V-8 with a Chevy three-speed stick transmission. Weighing in at a mere 2,400 pounds, Kiunke's "fiber-sports" could really move out with all that power. (Courtesy of Paul Kiunke.)

The early-1950s Fords, sometimes called "shoeboxes" because of their rectangular shape, provided a good, low-cost basis for customizing. This mildly customized 1950 model was owned by Dave Barker's brother Hal. Besides nosing the front, Hal added a set of the old spun-aluminum full-moon hubcaps to the gray two-door sedan. (Courtesy of Dave Barker.)

This 1958 Chevrolet Corvette, pictured at Sarzotti Park in Ojai, sports a paint job by famous Los Angeles customizer George Barris. He shaved the hood and trunk lid and painted the car candy-apple tangerine orange. The owner, Bill Dewar, added a set of aftermarket spinner hubcaps. (Courtesy of Dave Barker.)

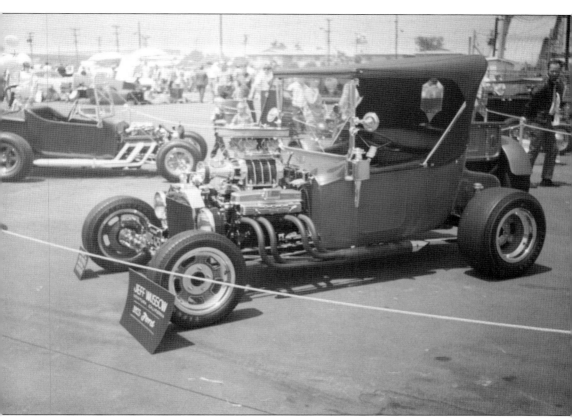

Here is a good example of a T-bucket or "kooky" hot-rod roadster. Owned by Ventura resident Jeff Wussow, this 1923 Ford has most of the features typical to its type, including lots of chrome plating, with the radiator shell, coach lamps, and mirrors finished in brass. The copper-colored bucket was moved by an impressive-looking blown Buick nailhead engine. (Courtesy of Jim Fain.)

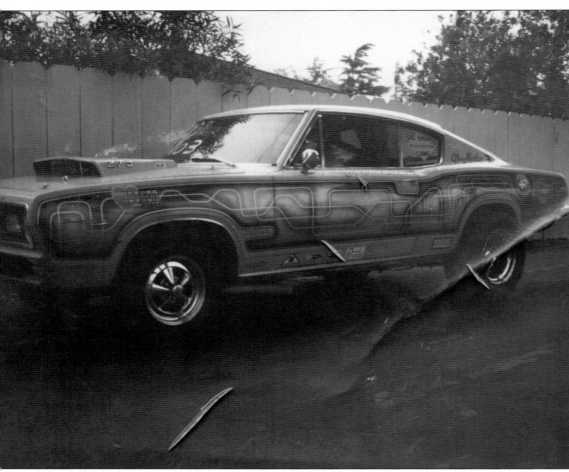

Oxnard resident and VCTA member Ed Chamberlain's 1967 Plymouth Barracuda Formula S displays a typical late-1960s custom paint job. This type of finish usually consisted of a solid color body with candy-colored panels on the sides. The side panels were then stenciled with lace or some other design in a third color, as seen here. (Courtesy of Ed Chamberlain.)

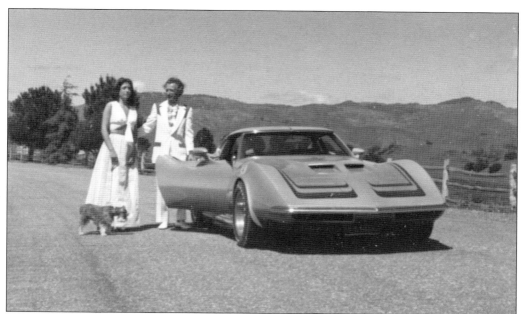

Sam Foose built this beautiful custom 1970 Chevrolet Corvette for Santa Paula racing legend Dave Marquez. Foose took a stock Corvette and extended the front and rear ends, giving the car a more shark-like appearance. He also added a set of running boards and installed rear-quarter windows to the cab. Foose really outdid himself with the paint job. Various shades of candy-apple green were layered on the body to create an effect that was darker on the low points of the body and lighter on the high points. Accent panels of a dark metallic green were painted on the nose. As with most candy-apple paint jobs, this one had to be seen to be appreciated. Dave Marquez's Corvette was featured in *Hot Rod* and *Car Craft* magazines and was later sold to film and television star Farrah Fawcett. (Both, courtesy of Mark Mendenhall.)

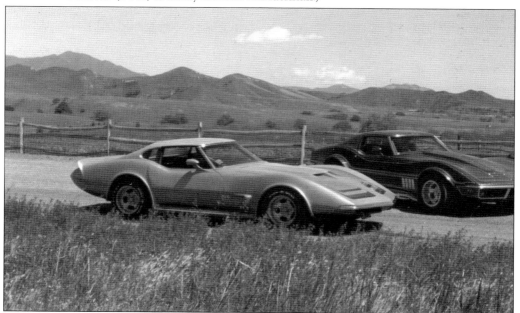

This interesting Model A Phaeton was spotted at a muffler shop on Ventura Avenue in the mid-1960s. The owner dropped a hopped-up V-8 engine in it and applied a glossy coat of paint. The fake wire-wheel hubcaps and homemade-looking nerf bar might be considered of questionable taste, but the person who built it probably had a lot of fun. (Courtesy of Dave Barker.)

Five

THE DRAG RACERS

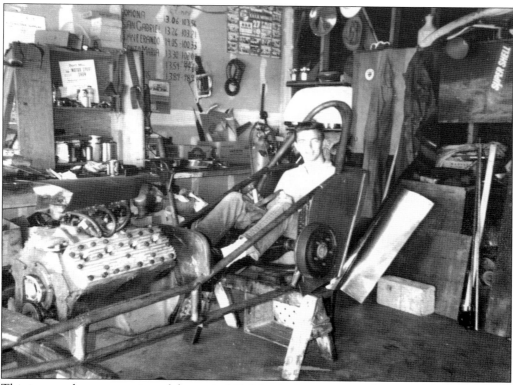

This is a good representation of the typical California drag-racing enthusiast of the early 1960s. He is probably not too long out of his high school automotive shop class, and note the big grin as he poses in the cockpit of his uncompleted dragster. The location is most likely his parent's garage, where he and a few friends are building it. It appears that he has already had quite a bit of racing experience, judging from the track times listed on the wall. Organized drag racing got its start in the region over a decade before this photograph was taken, and, by 1960, it was a full-blown national sport that was just beginning to become professional. In those days, it was still dominated by people who built their own cars over long hours after work and on weekends, and then spent race season going from strip to strip, burning up the quarter mile in a quest to have the fastest car around. (Courtesy of Bud Hammer.)

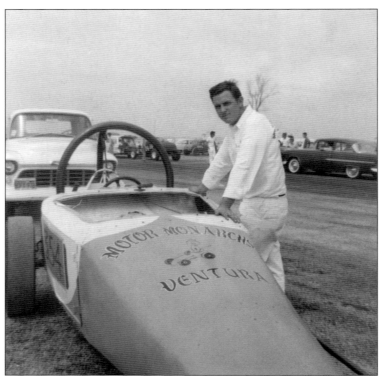

Howard Clarkson of the Motor Monarchs was one of the pioneers in the sport of drag racing. A charter member of the club, the Santa Paula native won fastest modified roadster at the 1956 NHRA Nationals in Kansas City, Missouri. Clarkson went on to own Cyclesmiths, Inc., of Rancho Cucamonga, California, a company that manufactures parts for Harley-Davidson motorcycles. (Courtesy of Lee Ledbetter.)

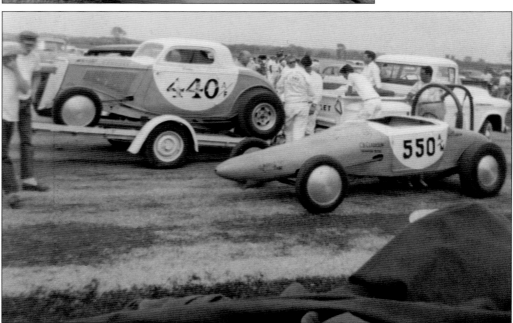

Howard Clarkson's mount for the 1956 nationals was the No. 550, seen here at Kansas City with Richard Martinez's modified coupe (No. 440). The No. 550, also known as "Cyrano," was the former Motor Monarchs club project dragster. Clarkson bought the car from the club and modified the body by adding the long nose cone. (Courtesy of Lee Ledbetter.)

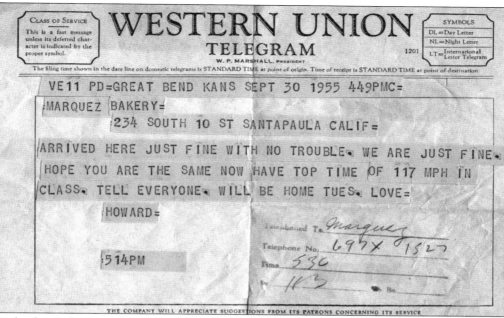

VE11 PD=GREAT BEND KANS SEPT 30 1955 449PMC=

MARQUEZ BAKERY=
234 SOUTH 10 ST SANTAPAULA CALIF=

ARRIVED HERE JUST FINE WITH NO TROUBLE. WE ARE JUST FINE.
HOPE YOU ARE THE SAME NOW HAVE TOP TIME OF 117 MPH IN
CLASS. TELL EVERYONE. WILL BE HOME TUES. LOVE=

HOWARD=

514PM

Telephoned To Marquez
Telephone No. 697X 1527
Time 536

In the days before e-mail and instant messaging, Western Union telegrams were the cheapest and quickest way to communicate over long distances. This one was sent by Howard Clarkson to let the folks back home to let them know that the Motor Monarchs car had won the Class B trophy in the 1955 nationals at Great Bend, Kansas. (Courtesy of Lee Ledbetter.)

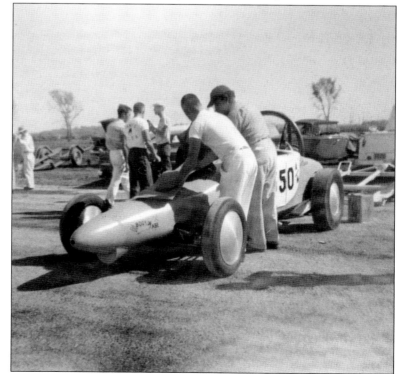

This view from Kansas City shows the nose cone extension to better advantage. Note the small air scoop visible beneath the nose. An unidentified member of the Motor Monarchs is leaning over the hood at left engaged in deep conversation with another unidentified individual, possibly a track official. (Courtesy of Lee Ledbetter.)

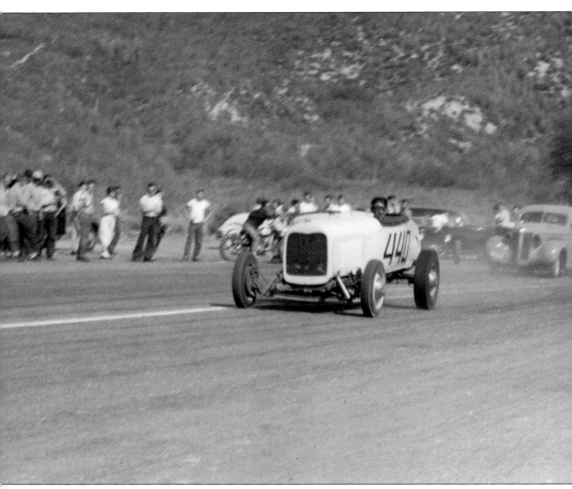

The chartreuse 1929 Ford Model A roadster belonging to the Motor Monarchs storms down the strip at Saugus on the day it took the track record with a top speed of 117.4 miles per hour in 1951. The little roadster was one of the first cars specially modified for quarter-mile drag racing. Driven by Eddie Martinez, the roadster suffered brake failure on this run and was almost wrecked, injuring Martinez in the process. (Courtesy of Lee Ledbetter.)

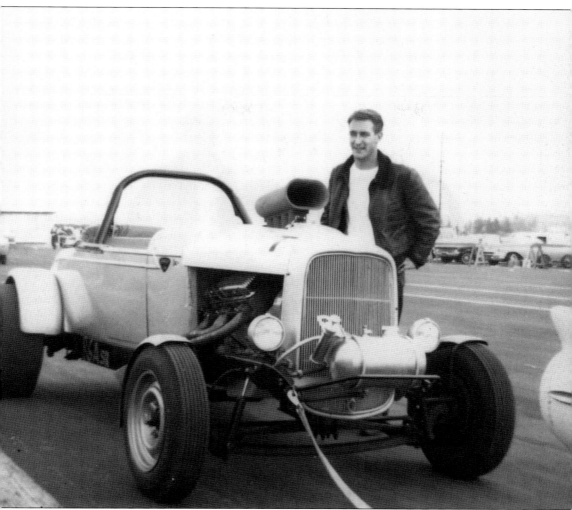

Undoubtedly, the most successful and famous driver to have lived in the county was the great Hugh Tucker. A native of Fresno, California, he moved to Ojai in 1956. Hugh would go on a winning streak that lasted from 1962 to 1967, sweeping the NHRA Nationals, NHRA Winternationals, and the March Meets in the Roadster class. He worked at his dad's paint-finishing business before taking a job as a mechanic at a Ventura Plymouth-DeSoto dealership and later as a machinist at American Brake Shoe in Oxnard. There, he began to develop skills in fabrication and engine-building that would serve him well throughout his career in racing. Hugh is seen here at the 1962 Winternationals with his famous 1928 Chevrolet, a car that had a long and interesting history. Built in a few days at practically no cost, it became for a time the fastest hot rod in the country. (Courtesy of Hugh Tucker.)

Hugh Tucker and friends built the car over three days in 1959. The rod's body came from a junkyard that used to be at the end of Shady Lane in Ojai. The entire car had been condemned to scrap, and Tucker (left) managed to talk the junkyard owner into giving him the body, fenders and all. Tucker used the Oldsmobile engine he had built for his 1949 Ford coupe, and its 1937 LaSalle transmission, too. (Courtesy of Jack Taylor.)

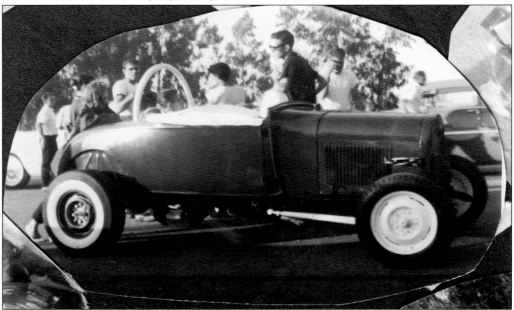

The competition in Hugh Tucker's first race was this Model A roadster belonging to the Chevrollers car club of Santa Barbara. The good-looking roadster was powered by a supercharged GMC 320 six-cylinder engine. The front-mounted GMC supercharger unit can be seen protruding from the rod's radiator grill. (Courtesy of Jack Taylor.)

Hugh Tucker began racing the roadster almost immediately, with his first venue being the well-known drag strip at Santa Maria. Seen here as they head for the staging lane are, from left to right, Tucker, Nick Sweetland (leaning on roll bar), and Ojai hot-rodder Roy Dimmick. (Courtesy of Bud Hammer.)

As can be seen in this somewhat blurry photograph, Hugh Tucker's hot rod was very fast. It was so fast, it won its first race and would remain almost unbeatable for several years to come. While somewhat rough in its initial configuration, the roadster would be refined over time, with many changes to the suspension, engine, drivetrain, and body. (Courtesy of Hugh Tucker.)

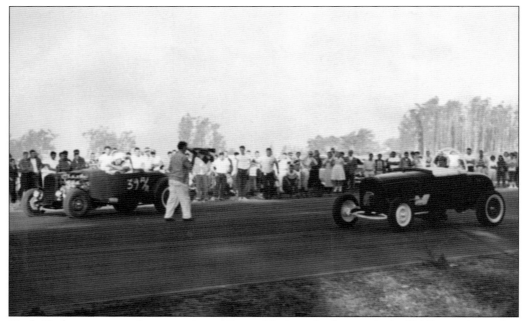

Hugh Tucker was a regular attraction at Santa Maria and other tracks in California during his early years. Here, he is beginning a duel with the Chev-rollers' Model A. Starter Don Doeckle can be seen at center with the checkered flag. (Courtesy of Bud Hammer.)

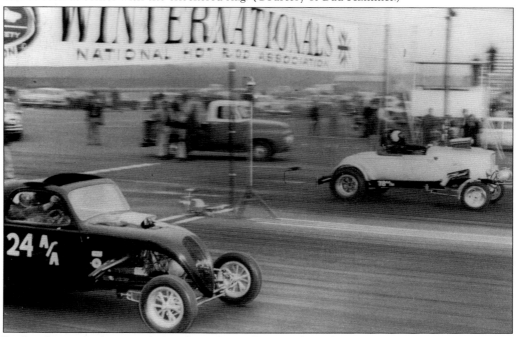

In this dramatic photograph, Hugh Tucker pulls away from the starting line to win the Junior Eliminator trophy at the 1963 NHRA Winternationals at Pomona, California. At left, in the Class "A" Fiat coupe, is another well-known Ventura county resident, Bob Culbert, of Oxnard. (Courtesy of Hugh Tucker.)

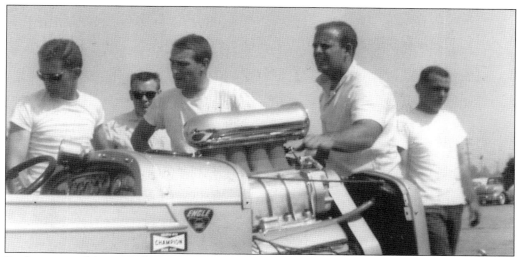

For his successful run in the 1963 Winternationals, Hugh Tucker partnered with noted engine builder Dave Stoll and was sponsored by Ventura Motors. In this view from the pits, the tension is apparent as Tucker (center), Stoll (second from right), and the crew prepare for the race. Also shown here are Bob Hunter (second from left) and Cliff Dysart (far right). The man at left is unidentified. (Courtesy of Hugh Tucker.)

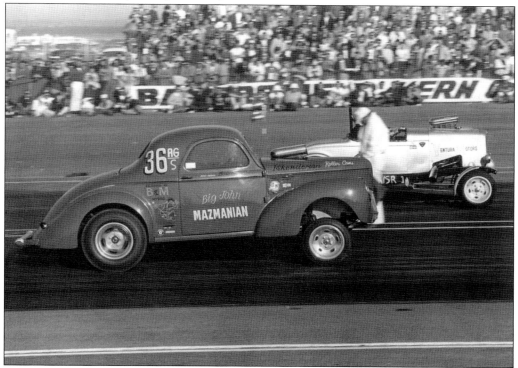

In the 1964 NHRA March Meet, held at Bakersfield's Famoso Raceway, Hugh Tucker went up against Big John Mazmanian's Chrysler-powered Willys, driven by "Bones" Balogh. Tucker would win this race, too, and Mazmanian hired him to drive the Winternationals-winning coupe for the rest of the spring and summer season of 1964. (Courtesy of Hugh Tucker.)

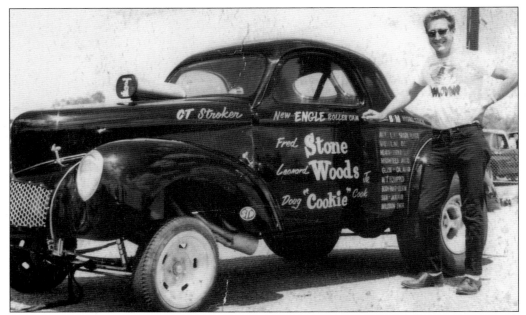

In 1965, Hugh Tucker became a relief driver for the biggest team in the gasser class—Stone, Woods & Cook. This photograph was taken just before Tucker was to engage in a match race with K.S. Pittman at Brazos Valley, Texas. Unfortunately, Pittman wrecked his blown Hemi-powered 1933 Willys in a practice run before that could happen. (Courtesy of Hugh Tucker.)

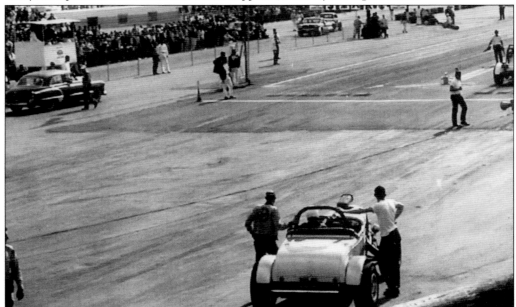

Hugh Tucker and the roadster, seen here at Pomona in 1962, would race until 1967. Among the NHRA titles Tucker has held are the following: 1962 Little Eliminator, 1963 Middle Eliminator, 1966 Super Eliminator, and Eliminator runner-up in the 1967 Winternationals. He was the Class Eliminator in the 1963 March Meet at Bakersfield. Tucker went on to a career in the Los Angeles Fire Department. (Courtesy of Hugh Tucker.)

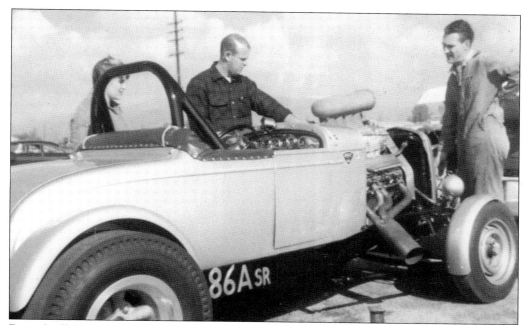

Dave Stoll (center), of Bardsdale Ranch, supplied the blown Oldsmobile engine and B&M transmission as well as other parts used to power Hugh Tucker's roadster to victory in the 1963 Winternationals. Big blown Hemi-conversions of GM engines built by Stoll powered quite a few dragsters and drag boats in the 1960s. (Courtesy of Dave Stoll.)

Dave Stoll raced a 1932 Ford coupe and towed it with this neat 1957 Chevy Bel Air, seen parked on a Fillmore street. Both cars had Chevy small blocks bored out to 352 cubic inches. The Deuce also was equipped with a GMC 471 blower and a B&M four-speed hydro transmission. (Courtesy of Dave Stoll.)

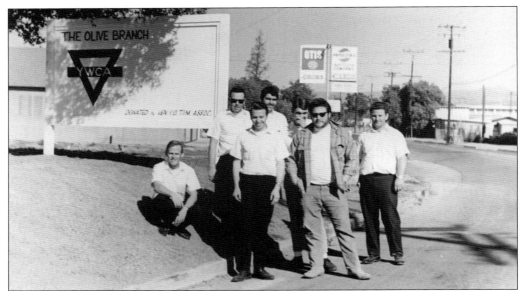

Members of the Ventura County Timing Association are seen in the early 1970s at a clubhouse they refurbished for the local YWCA as a public service. The location is the corner of Olive and Lewis Streets in Ventura. Shown here are, from left to right, Chuck Roberts, Bill Hahn, Jim Fain, Paul Mercado, Doug Thomas, Walt Kenyon, and Bill Kenyon. (Courtesy of Jim Fain.)

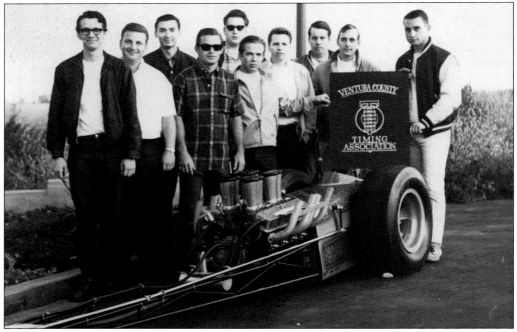

The Ventura County Timing Association (VCTA) was formed in the late 1960s, long after the heyday of the Ventura car club scene a decade before. As with other clubs, its main objective was to have a safe, legal place to race. These members are, from left to right, Keith Pevyhouse, Phil Deardorf, Jim Campbell, Alan Scoggins, unidentified, Jim Fain, George Farmer, Gary Eckenroad, unidentified, and Nate Duty. (Courtesy of Jim Fain.)

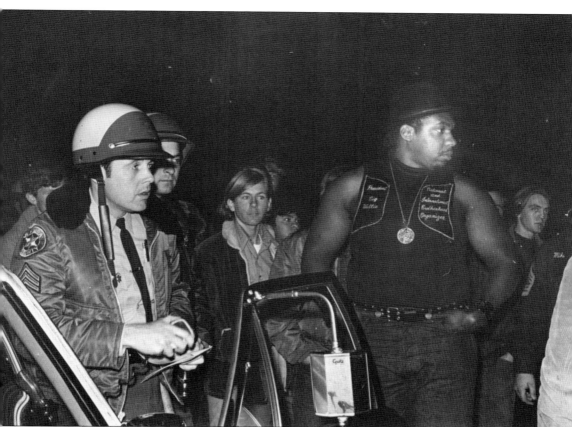

As with previous generations of Ventura hot-rodders, the members of the VCTA had the option of racing on the county back roads or traveling far distances to race legally. By 1970, most of the street racing in Ventura was done along Olivas Park Road in the direction of the beach. On some nights, hundreds of kids would show up, and it was then that the movement to open a legal drag strip in the area began. The VCTA began to petition city hall to have a strip established, and it was quite a local controversy at the time. In order to publicize its cause, the club invited legendary street racer Big Willie Robinson (center right) from Los Angeles to draw a crowd. And that he did, as can be seen here. Although law enforcement was called in by nervous officials, the crowd dispersed with no problems. Events like this were successful and went a long way to prove drag racing's popularity to the county board of supervisors. Eventually, conditional permission was granted to use the airstrip at the recently vacated Oxnard Air Force Base. (Courtesy of Jim Fain.)

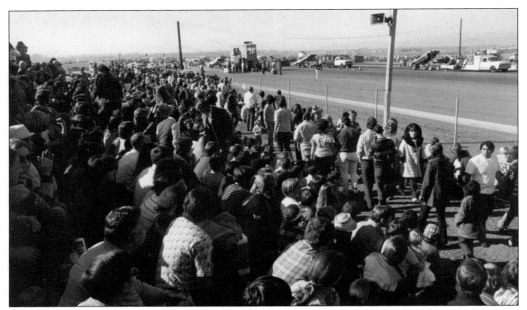

The first race day was scheduled for July 11, 1971, and the VCTA estimated the event would draw around 5,000 spectators. When the gates opened, a crowd of over 30,000 people came through, causing the day to be referred to locally as the "Woodstock of Racing." Note the control tower at center and the funny cars staging at right. (Courtesy of Jim Fain.)

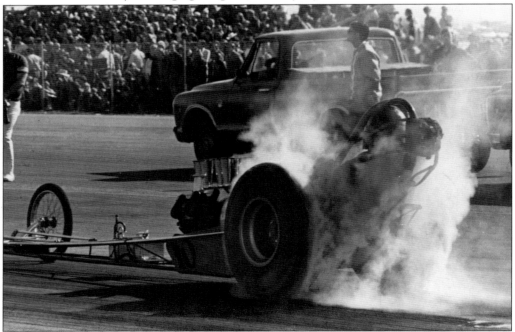

Traffic on access roads to the strip was jammed for miles around. Admission on the first day was $3.50. The event's huge success led to plans for a series of race days beginning in February 1972. Here, a Junior Eliminator class dragster "smokes" its wheels to get better traction before a race. (Courtesy of Jim Fain.)

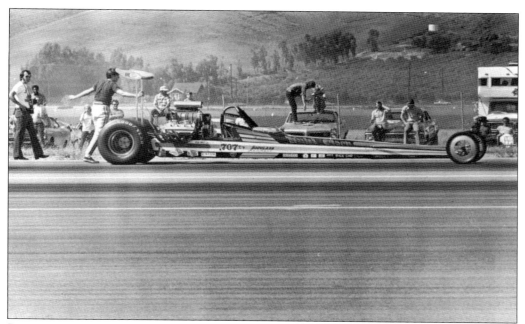

Future NHRA executive Karl Olson is seen pushing his fueler across the finish line after experiencing a breakdown on the strip at the former Oxnard Air Force Base. The other driver in the race broke down, too, so Olson was able to claim a win. Visible in the background are the foothills of the Santa Monica Mountains. (Courtesy of Jim Fain.)

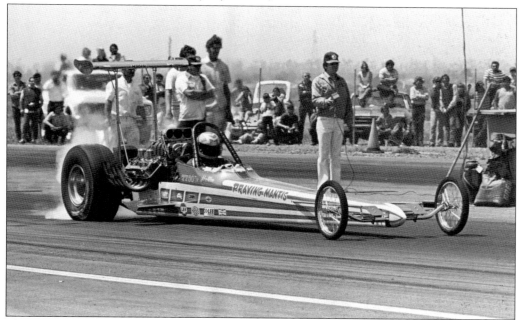

The "Praying Mantis" dragster is seen just beginning its run down the strip. Note the rear mounted Hemi engine and the various airfoils to help keep the racer's nose down. Wheelies, although popular with the spectators, usually cost the driver a race. Starter Jim Fain is seen at right, holding timing light controls. (Courtesy of Jim Fain.)

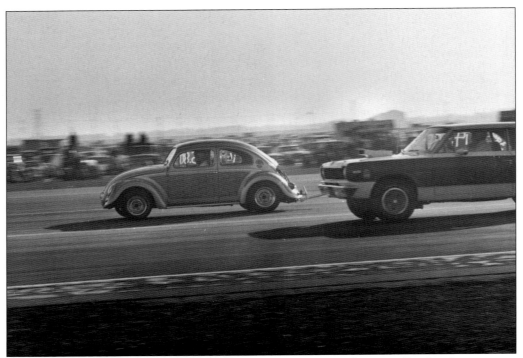

A Volkswagen Beetle takes on a 1966 Rambler in what was known as an ET (elapsed time) bracket race. Different class Eliminators would be put in a race to see which could reach a certain speed and time that was determined beforehand. This was similar to the "handicapping" that goes on in the world of horse racing. (Courtesy of Jim Fain.)

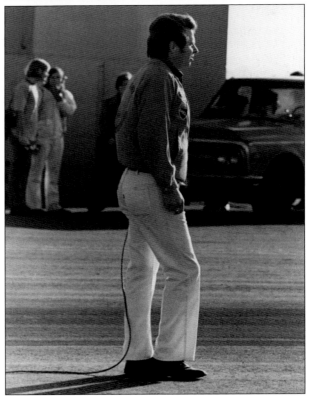

President of the VCTA and prime mover in the push to establish a drag strip in the county was Jim Fain, seen here in his role as starter at the Ventura County Drags. A 1960 graduate of Ventura High School, Fain ran his own business, Fain's Auto Parts & Machine Shop, for over 30 years before retiring. (Courtesy of Jim Fain.)

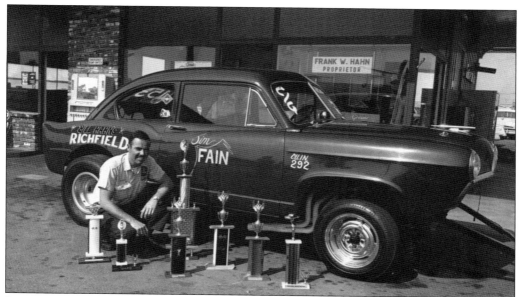

Jim Fain teamed up with Bill Hahn (pictured) to race this 1951 Henry J gasser. Hahn's family operated a Richfield service station in Ventura, and Bill was Fain's partner for several years. Here, the winning Henry J is shown in its original paint scheme, a candy-apple red color with gold lettering. (Courtesy of Jim Fain.)

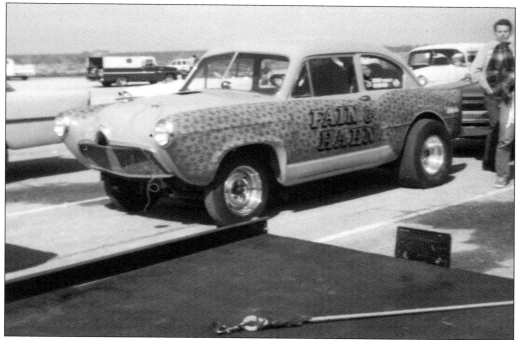

Jim Fain would later paint the Henry J a candy-apple green shade and add gold lace stenciling. Lace stenciling was a very popular painting technique in the 1960s and early 1970s. Fain's gasser ran on a 283 Chevrolet engine bored out to 292 cubic inches and equipped with a Hilborn fuel-injection system. (Courtesy of Jim Fain.)

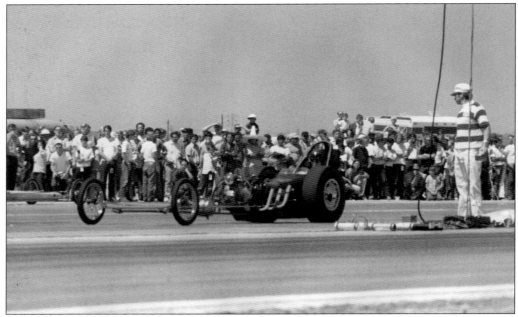

Joey Sweetland is seen here on the Ventura Drags' starting line in the Gas dragster that he inherited from his big brother Nick. The engine is the venerable Ford flathead unit that powered Bob Culbert, Asher and Henry, and Jack Taylor. Starter Jim Fain stands at right. (Courtesy of Bud Hammer.)

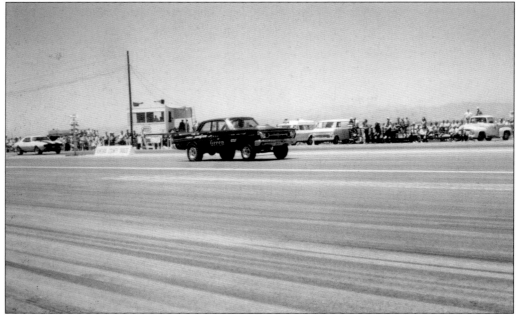

A 1965 Ford Fairlane hauls down the track at the Ventura County Drags. Visible behind and to the left of the car is the drag strip's control tower, and to the left of that is the set of "Christmas tree" starting lights. The Chevrolet Camaro at far left sits at the starting line—either the Ford really got a jump, or this was just a qualifying run. (Courtesy of Ed Chamberlain.)

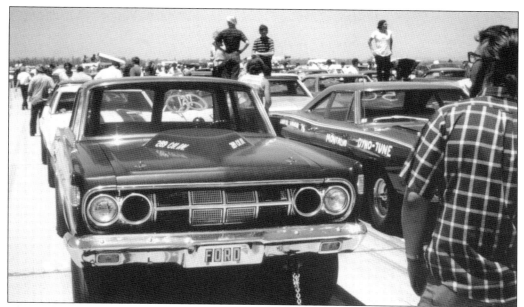

This is the crowded pit area at the Ventura County Drags. There were a total of seven drag-race meets at Oxnard Air Force Base, with the last one being held on June 4, 1972. The Ventura County Drags were more successful than anyone could have imagined, but the success was short-lived. Complaints about noise and pressure from the county brought an end to the meets, and the members of the VCTA went on to other pursuits, like raising families and starting careers. (Courtesy of Ed Chamberlain.)

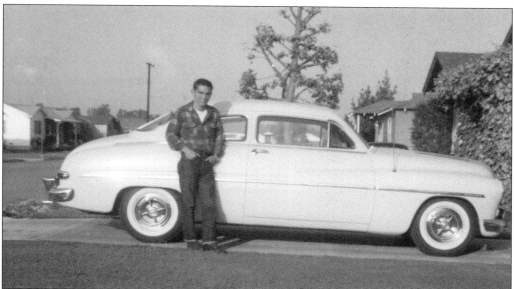

Cliff Dysart, a 1958 graduate of Ventura High School, was another Ventura native who became very active in the Southern California drag-racing scene. In this 1957 photograph, the high school junior proudly leans on his 1949 Mercury. The mild custom features a baby blue paint job and custom interior work. Flashy aftermarket "spinner" hubcaps and a lowered front end completed this otherwise stock example. (Courtesy of Cliff Dysart.)

Cliff Dysart is seen here in the Chrysler-powered lakester belonging to his cousin Art Chrisman, at Chrisman's Compton, California, garage in 1955. The bronze-colored coupe, built by Chrisman, was one of the first cars to go over 200 miles per hour at Bonneville Salt Flats. The "nose-cone" front bodywork was fabricated from two 1940 Ford hoods. Cliff's little sister Carol is at left. (Courtesy of Cliff Dysart.)

By his senior year, Cliff Dysart had gone from a mild custom to this rather mean-looking 1955 Oldsmobile. Nosed, decked, and painted silver-blue by the Farar Auto Body Shop, this was Dysart's first street rod. He powered it with a hopped-up 1957 Oldsmobile J2 engine and a Buick three-speed transmission. (Both, courtesy of Cliff Dysart.)

Like many California hot-rodders, Cliff Dysart went to Tijuana for the well-crafted vinyl tuck-and-roll upholstery. The seats and side panels are black and silver-blue, and the dashboard is painted gloss black with a metallic gold inset. Dysart's Olds was one of the fastest rods around, usually challenged only by Ken Dutweiller's hot rod. (Courtesy of Cliff Dysart.)

This is the junkyard Olds J2 V-8 that Cliff Dysart rebuilt and installed in his rod. The big 371-cubic-inch overhead J2 was considered Oldsmobile's hot engine at the time. Note the small bumps on the valve covers, which are there to clear the adjustable rocker-arm nuts. This was unique to the J2. (Courtesy of Cliff Dysart.)

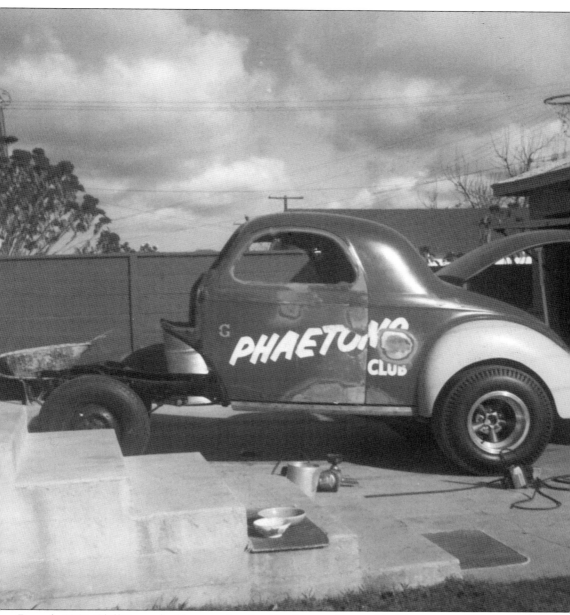

By early 1964, Cliff Dysart had become involved in the growing world of drag racing. The "gasser wars" were raging at the local drag strips, and the NHRA had modified the rules to allow lighter-weight, gasoline-burning vehicles to race as a separate class. The iconic 1940 Willys coupe, with its small size and ability to hold any size engine, was the favorite of racers. Dysart and friend Mike Thatcher acquired this veteran example from the Phaetons car club of Ojai. (Courtesy of Cliff Dysart.)

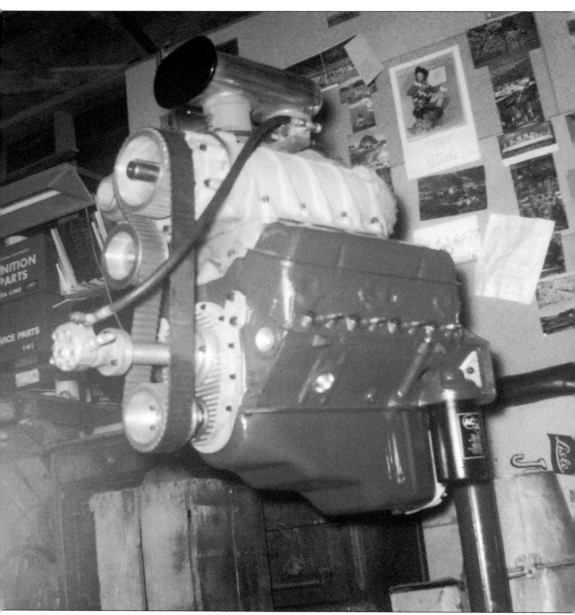

Not having the resources to build a big and expensive engine for A/Gasser class racing, Dysart decided to wring as much horsepower as he could from a supercharged, small-displacement engine and race in the lighter C/Gasser class. He started with an early, "generation one" 265-cubic-inch Chevy small block and de-stroked it to 228 cubic inches. Seen on top in this photograph is a GMC 671 blower with a single Hilborn injector. After many teething problems, Dysart managed to get a fairly reliable 700 horsepower out of the engine. (Courtesy of Cliff Dysart.)

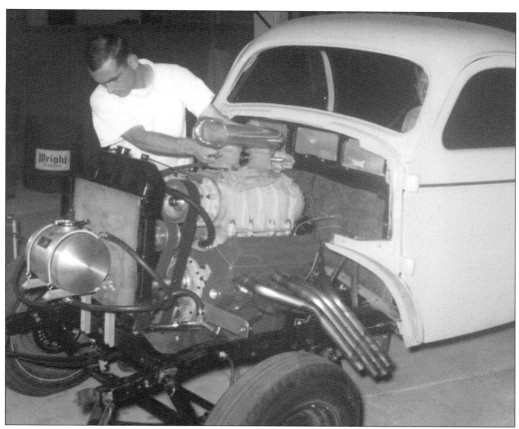

Mike Thatcher sold his share of the Willys to Cliff Dysart early on. Dysart is seen here with the car shortly after the engine has been installed. Of interest are the Moon fuel tank and the highly arched leaf-springs on the front suspension. The rest of the front end and the steering gear came from a 1957 Pontiac. This was considered to be the best setup for a Willys gasser. (Courtesy of Cliff Dysart.)

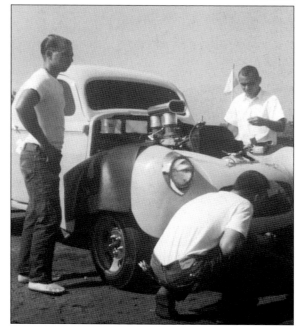

Cliff Dysart (center) is at San Fernando Drag Strip, on the new gasser's first outing, eight months after starting his project. It has been painted with chromium yellow lacquer base coat paint, acquired from Cliff's employer, L.N. Dietrich Automotive, where many a Ventura hot-rodder worked at one time or another. The other two individuals are unidentified. (Courtesy of Cliff Dysart.)

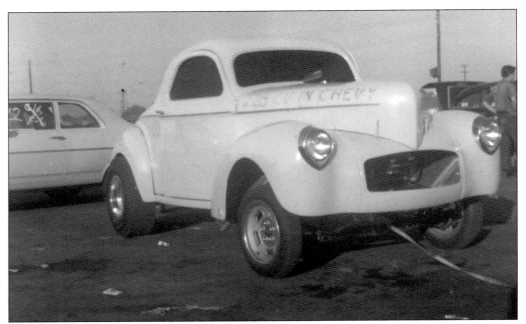

Dysart would race the Willys throughout the 1964–1965 season with a good degree of success, winning the *Hot Rod* magazine trophy for supercharged C/gasser class cars at Riverside, California, in June 1965 against a lot of competition. Note the Cal-Automotive fiberglass front body and Halibrand slotted mag wheels. (Courtesy of Cliff Dysart.)

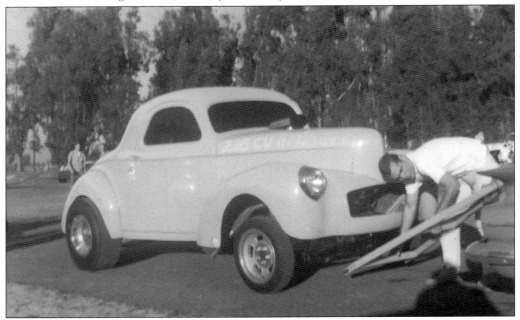

The end for Cliff Dysart's involvement with the Willys came in mid-1965 at Santa Maria. Fuel-injection problems led to three burned pistons during a race. The expense involved in replacing three custom-made pistons, combined with the fact that Dysart was going to get married, made selling the gasser a necessity. (Courtesy of Cliff Dysart.)

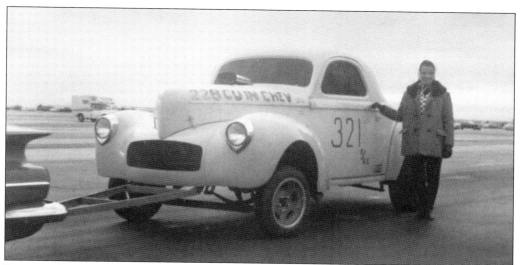

By 1966, changes in NHRA rules allowed smaller foreign makes, such as supercharged Opals, to race as C/gassers. This spelled the end for the reign of the older Willys in that class. Cliff Dysart sold the obsolete gasser to Tim Woods of Stone, Woods & Cook Racing. That team raced it for a time. Today, it is believed to be on display in the NHRA Museum at Pomona, California. (Courtesy of Cliff Dysart.)

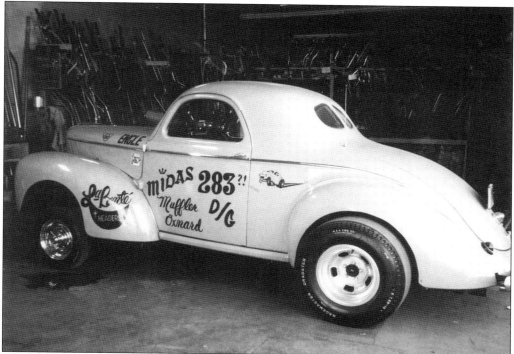

Another local Willys gasser was this D class owned by Fred La Bonte of Oxnard. The bright-yellow coupe was powered by a Chevrolet 327 with a Rochester blower. The transmission was a B&M Hydramatic. In the background are the exhaust pipes and mufflers that were the stock of La Bonte's Midas Muffler shop. (Courtesy of Bud Hammer.)

Fred La Bonte was an Oxnard businessman who was heavily involved in the Central Coast drag-racing scene of the late 1950s and early 1960s. Well known and respected by the local drag-racing community, La Bonte operated a Midas Muffler shop, where he also built race engines and made his facilities available to all. Here, La Bonte (left) poses in his shop with another well-known local racer of the day, Carl Nietzsche, as they show off a pair of just-completed fuel-injected Chevy small-block engines. (Courtesy of Bud Hammer.)

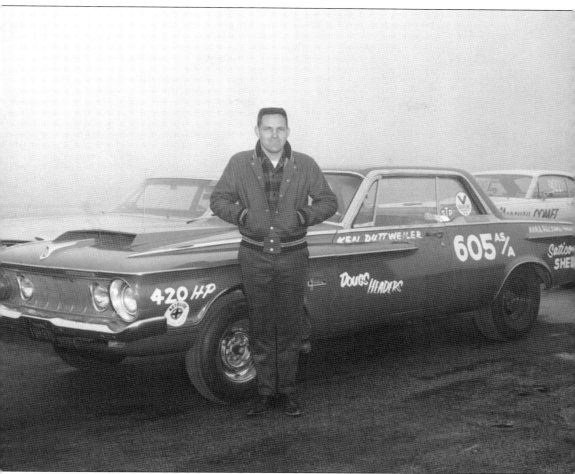

One of the finest and most illustrious engine builders in the region is Ken Duttweiler. The Saticoy native and 1957 graduate of Ventura High School first gained notoriety in the 1980s for his work on the turbocharged 1984 Buick Grand National Stock Eliminator for *Hot Rod* magazine. Since then, he has become known for extracting unbelievable amounts of horsepower from small-displacement engines, as well as his research into the science of turbocharging. Combining great mechanical skill with an uncanny understanding of the engineering of racing engines, Duttweiler currently operates Duttweiler Performance in his hometown of Saticoy. There, he develops and builds high-performance turbocharged engines for dragsters and lake streamliners and acts as a consultant for speed-equipment manufacturers. He is seen here in the mid-1960s with his 1962 Plymouth Sport Fury Hardtop, which he ran in the Stock class. These came factory-equipped with the big 413-cubic-inch Hemi, which made the Plymouths (and Dodges, too) hard to beat at the drag strip. (Courtesy of Ken Duttweiler.)

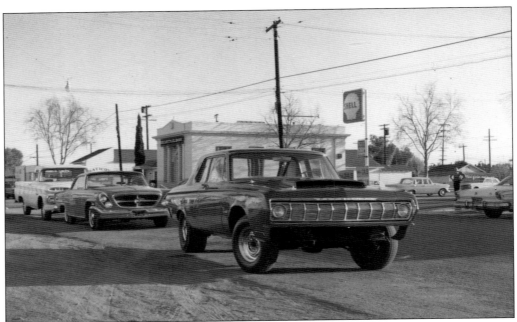

A few years later, Ken Duttweiler upgraded to this 1964 Plymouth Sport Fury, seen here before modification on Los Angeles Avenue in Saticoy. In the background are a few old Saticoy landmarks, like the Security Pacific Bank (center) and Ken's sponsor, Saticoy Shell (right). Note the price of gasoline, 34.5¢ per gallon. (Courtesy of Ken Duttweiler.)

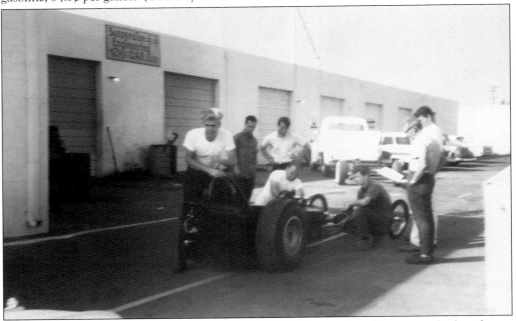

As dragsters progressed from primitive machines made from junkyard parts to vehicles of more sophistication, companies like Chassis Research, Dragmaster, and Suspension Engineering of Oxnard (pictured) began offering chassis kits and other parts that were specially engineered for drag racing. (Courtesy of Bud Hammer.)

When a chassis kit was purchased from a company like Dragmaster, the buyer received the following: several lengths of high-strength chrome-moly tube (some bent to shape), machined shackles, fittings, and housings for the rear axle. Everything else had to be assembled and added by the owner. (Courtesy of Bud Hammer.)

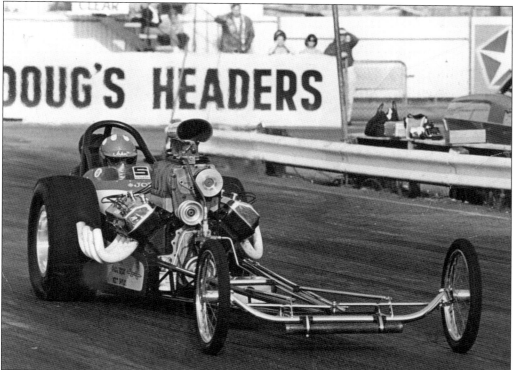

Ventura resident John Farr is known as one of the finest builders of top-fuel dragsters in the country. In this classic photograph from the late 1960s, Farr tools down the Lions Drag Strip in his Hemi-powered fueler. His shop in Ventura has produced dragsters and hot rods for over 50 years. (Courtesy of John Farr.)

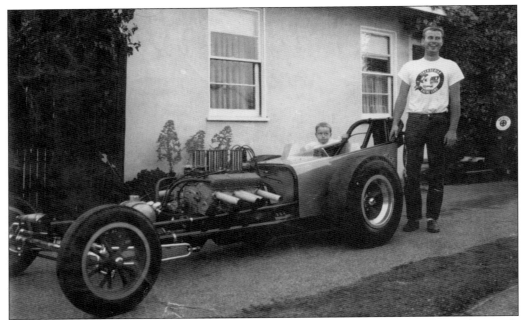

Pennsylvania native Fred Notzka moved to Oxnard as a teenager in 1960 and joined up with the Pharaohs almost immediately. This was a goal of his ever since reading about the club's accomplishments in *Hot Rod* magazine. Notzka began racing both his own and others' dragsters, and quickly became known as a "racer's racer." (Courtesy of Fred Notzka.)

This is the Asher and Henry injected-fuel dragster that held the track record at Lions Drag Strip in the sixties. It was built by Tom Henry and owned by Dewey Asher. The flathead engine was originally built and raced by Bob Culbert, and it later powered the dragster shown here. It then went into Jack Taylor's 1950 Ford gasser. Note the Moon fuel tank up front. (Courtesy of Bud Hammer.)

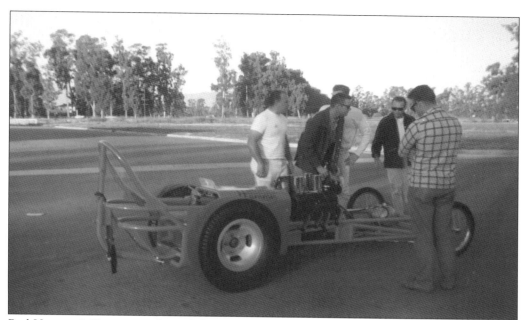

Bud Hammer's Dragmaster-framed dragster is seen here on a late afternoon in Oxnard around 1960. The bare-bones racer originally ran a Mercury flathead, which was replaced with the small-block Chevrolet engine seen here. Hammer wore an early version of a full Nomex fire suit while riding in the fully exposed cockpit. (Courtesy of Bud Hammer.)

Here is a view of the Spartan cockpit arrangement typical of a late-1950s dragster—in this case, Bud Hammer's. A seat fashioned from extruded steel mesh and no padding offers little comfort, but it at least makes a strong anchor for the safety belts. A "butterfly" steering wheel protrudes from underneath the windscreen, and the handbrake lever is at left. (Courtesy of Bud Hammer.)

This early-1970s photograph of a funny car cockpit at the Ventura County Drags gives some idea of the claustrophobic conditions experienced by the drivers. This driver wears a full suit made of fire-resistant material, including face mask, boots, and gloves. The metal cylinder attached to the steering column is a Halon fire extinguisher. (Courtesy of Jim Fain.)

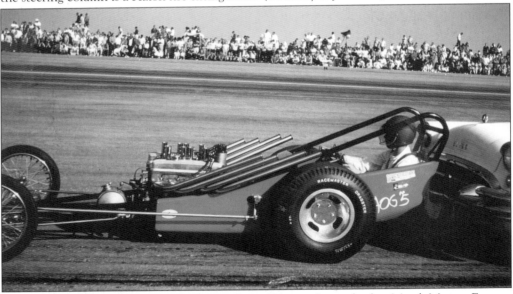

Bud Hammer took this photograph of racing legend Tommy Ivo at the first March Meet at Famoso Drag Strip in Bakersfield, California, in 1959. Ivo's A-class open-gas dragster was built around a Kip Fuller frame. Note the straight exhaust pipes coming out of the Hilborn-injected Buick nailhead. (Courtesy of Bud Hammer.)

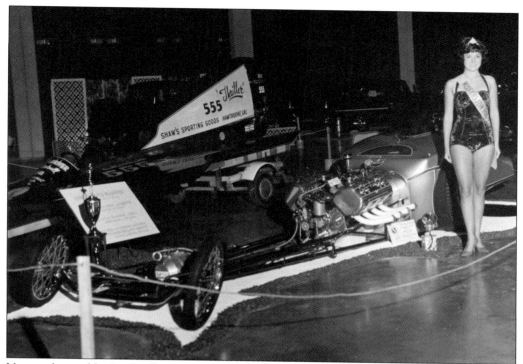

Veteran hot-rodder Lee Ledbetter built this dragster in the mid-1960s. Produced strictly for show and never raced, Ledbetter's first dragster featured a Cal-Glass body mounted on a chromed Dragmaster frame. The Ardun-Ford engine was built by Bob Joehnk and had previously powered Dave Marquez's award-winning roadster, the "No. 880." (Courtesy of Lee Ledbetter.)

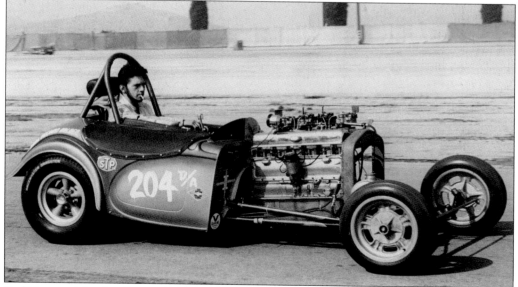

Bud Hammer's brother Bernard ran this all-fiberglass-bodied roadster in the 1966 Winternationals. Painted silver with metallic-green shading, it was powered by the venerable 320-cubic-inch GMC straight-six that Bud used in his dragster in the late 1950s. (Courtesy of Bernard Hammer.)

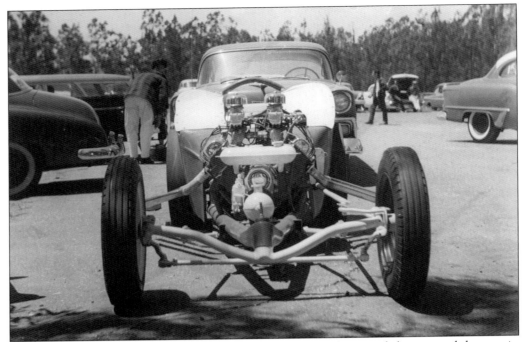

The Dwarfs car club, of which Bernard Hammer was a member, raced this unusual dragster in the late 1950s. The design was based on an odd triangular frame by Suspension Engineering. The front axle was attached to the "point" of the frame, and shock was absorbed by a single, large, rubber donut bushing. The handling was described as erratic. (Courtesy of Bud Hammer.)

Ventura County Timing Association member Paul Mercado is seen here at Lions Drag Strip in 1971. His green 1956 Chevrolet Delray coupe had a small-block 283 engine bored out to 303 cubic inches. The conventionally aspirated stocker was able to run the quarter mile in 12.20 seconds. It was named the "Frito Bandito," after a popular snack-food advertisement of the day. (Courtesy of Paul Mercado.)

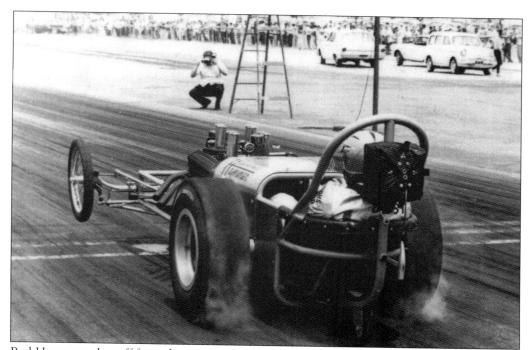

Bud Hammer takes off from the starting line at Pomona. The small castor wheel, visible under the rear of the dragster, was there to prevent uncontrollable wheelies. There was little weight to keep the front wheels down, so the castor wheel restricted the front end's movement. Note the English Ford estate wagon in the background at right. (Courtesy of Bud Hammer.)

This is a good example of what a well-equipped dragster interior of the late 1950s looked like. A small tachometer and oil-pressure gauge are on the dash, and the steering wheel came from a fighter plane. The driver was cushioned by vinyl pads on either side and protected from sometimes explosive differential failure by a welded tread-plate box. (Courtesy of Lee Ledbetter.)

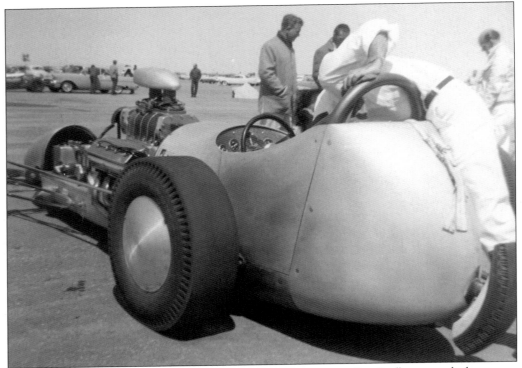

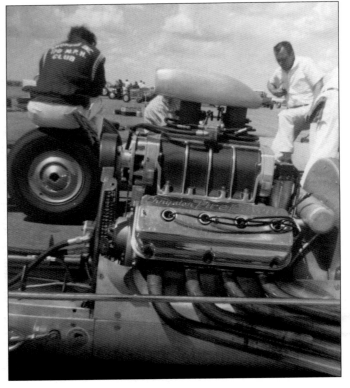

Lee Ledbetter took these two photographs of Art and Lloyd Chrisman's famous Hustler 1 AA/Fuel dragster at Bakersfield in 1959, on the day it won the first March Meet. The mighty 454-cubic-inch Hilborn fuel-injected Chrysler Fire Power Hemi engine was built by Frank Canno. Also shown is the wraparound, unpainted aluminum body by Red Rose. The Hustler was truly the state of the art for drag racers, and *Hot Rod* magazine called it the best-engineered dragster ever built. At Riverside Raceway, the dragster set an official record of 181.81 miles per hour and 8.54 seconds in the quarter mile. In the left photograph, Art Chrisman is visible just to the right of the blower air intake. (Both, courtesy of Lee Ledbetter.)

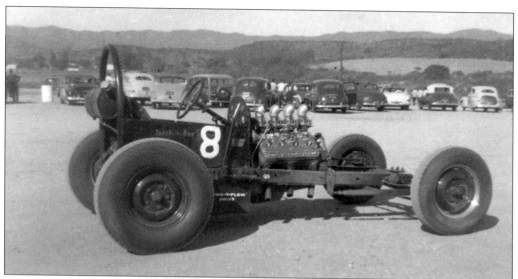

These photographs of early "rail" dragsters at Saugus Drag Strip around 1953 illustrate the crude construction methods that made up the first cars. The flathead-powered rail in the above photograph at least offers the driver a little protection with a semi-enclosed cockpit. The tube-framed example shown below looks frighteningly dangerous, with the driver exposed to the elements. Also, note the positioning of the steering column. Both dragsters had some rollover protection, although the fuel tanks are located behind the driver's head. Drivers wore little or no safety gear in those days, but fatal accidents were surprisingly rare. (Both, courtesy of Lee Ledbetter.)

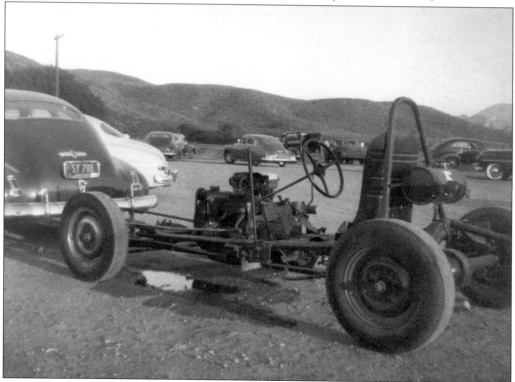

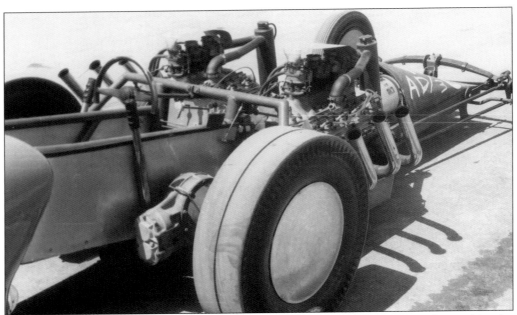

Twin-engine dragsters have been around since the early days of the sport, with cars like the "Bustlebomb" and the "Bean Bandit" appearing in the mid-1950s. Most engines were mounted in tandem or inline fashion. One that bucked the trend, mounting them side by side, was the "Outlaw," built and raced by "Jazzy" Jim Nelson. The Outlaw was powered by two nitro-burning Mercury flatheads that were attached to a special frame that also contained engine coolant. The two cylinders visible in front of each engine acted as heat exchangers and also transferred coolant from the engines to the reservoirs in the frame. Nelson later replaced the flatheads with a pair of bigger blown Oldsmobile engines, which added too much weight and power, adversely affecting the Outlaw's performance. He sold it shortly after, and a re-creation, using many original parts, is in existence today. (Both, courtesy of Lee Ledbetter.)

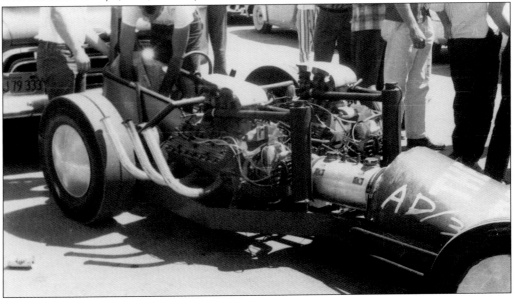

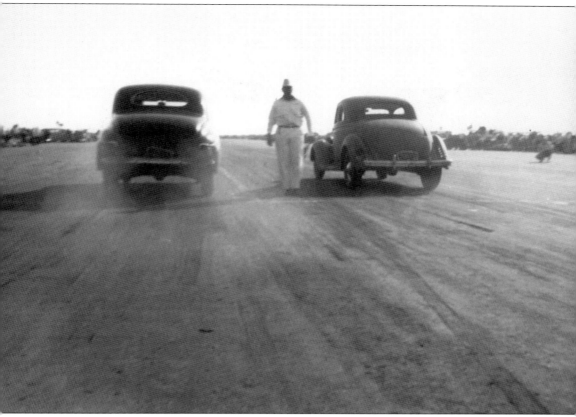

This look back at the county's motor sports ends with a photograph of Eddie Martinez acting as starter in a race between two street rods sometime in the early 1950s. Ventura County continues to be the home of a diverse motor-sports scene, with numerous speed shops doing good business, a full car-show season, and a very active dirt-track racing season at Seaside Park. While the technology of motor sports may change as the internal combustion engine is eventually supplanted by other means of propulsion, no doubt, the race to be the fastest in the county will continue for some time. (Courtesy of Howard Clarkson.)